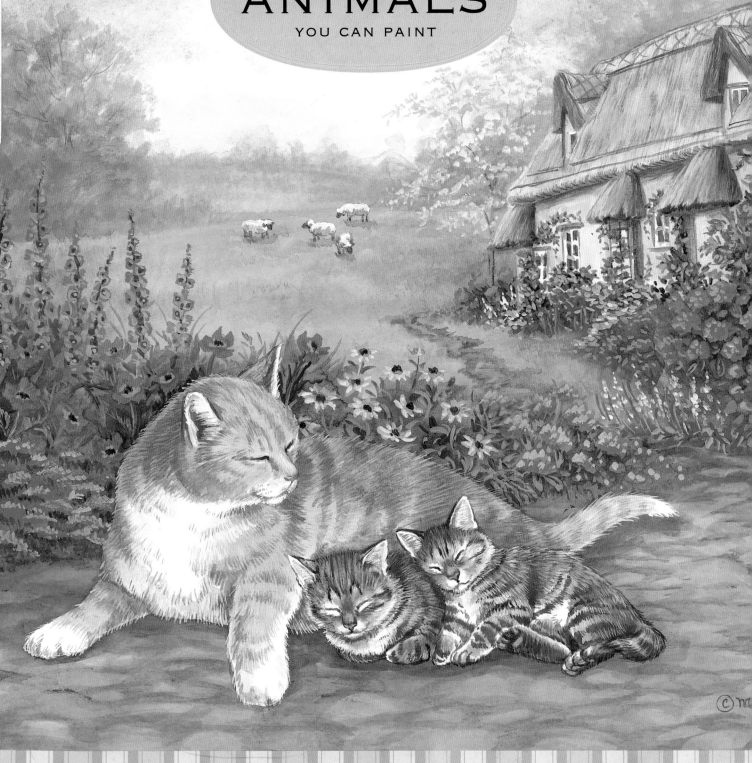

cute country
ANIMALS
YOU CAN PAINT

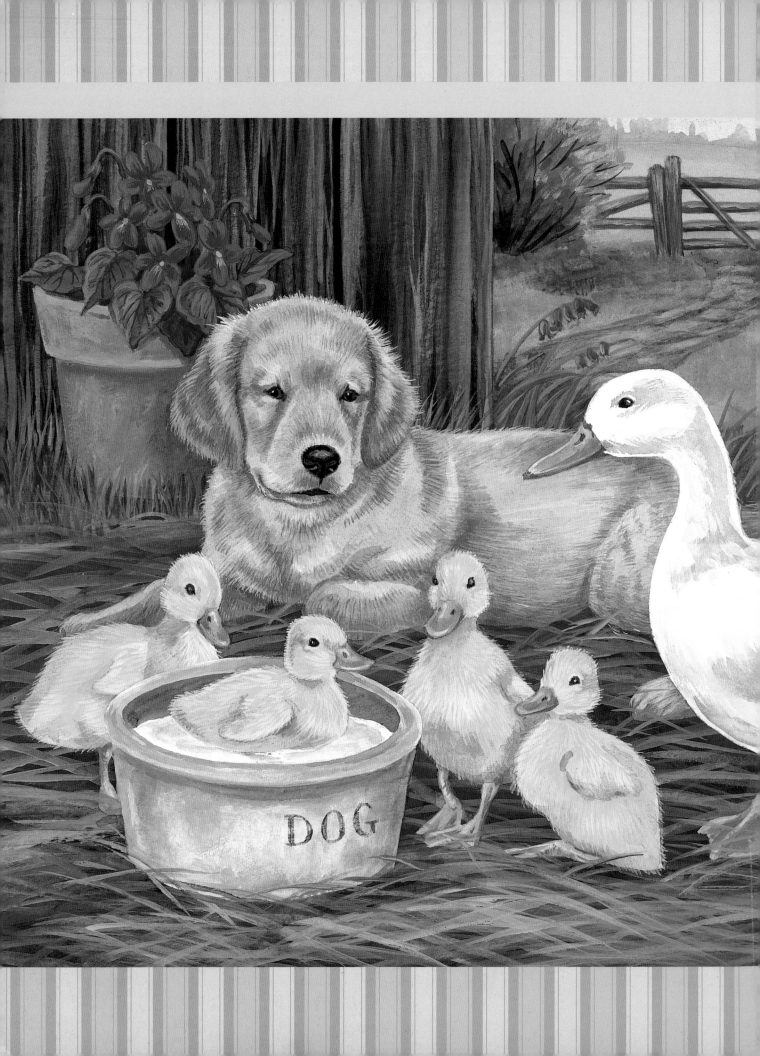

cute country
ANIMALS
YOU CAN PAINT

Jane Maday

NORTH LIGHT BOOKS
CINCINNATI, OHIO
www.artistsnetwork.com

Cute Country Animals You Can Paint. Copyright © 2007 by Jane Maday. Manufactured in China. All rights reserved. No part of this book may be reproduced in any form or by any electronic or mechanical means including information storage and retrieval systems without permission in writing from the publisher, except by a reviewer who may quote brief passages in a review. Published by North Light Books, an imprint of F+W Publications, Inc., 4700 East Galbraith Road, Cincinnati, Ohio, 45236. (800) 289-0963. First Edition.

Other fine North Light Books are available from your local bookstore, art supply store or direct from the publisher at www.fwbookstore.com.

11 10 09 08 07 5 4 3 2 1

Distributed in Canada by Fraser Direct
100 Armstrong Avenue
Georgetown, ON, Canada L7G 5S4
Tel: (905) 877-4411

Distributed in the U.K. and Europe by David & Charles
Brunel House, Newton Abbot, Devon, TQ12. 4PU, England
Tel: (+44) 1626 323200, Fax: (+44) 1626 323319
Email: postmaster@davidandcharles.co.uk

Distributed in Australia by Capricorn Link
P.O. Box 704, Windsor NSW, 2756 Australia
Tel: (02) 4577-3555

Library of Congress Cataloging in Publication Data
Maday, Jane.
 Cute country animals you can paint / Jane Maday.
 p. cm.
 Includes index.
 ISBN-13: 978-1-58180-975-6 (pbk. : alk. paper)
 1. Painting--Technique. 2. Domestic animals in art. 3. Landscape in art. I. Title.
ND1473.M332 2008
751.4'26--dc22
 2007019169

Edited by Jacqueline Musser
Designed by Clare Finney
Production coordinated by Greg Nock

ABOUT THE AUTHOR

Born in England and raised in the United States, Jane Maday has been a professional artist since she was fourteen years old. At sixteen, she was hired as a scientific illustrator at the University of Florida. After graduating from the Ringling School of Art and Design, she was recruited by Hallmark Cards, Inc. as a greeting card illustrator. She left the corporate world after her children were born; she now licenses her work onto numerous products such as cards, puzzles, needlework kits, T-shirts, etc., and she writes art instruction books and articles. She is the author of four books, including *Adorable Animals You Can Paint* (North Light Books).

Jane now lives in scenic Colorado with her husband and two children and a menagerie of animals. You can see more of her work or contact her through her Web site, www.janemaday.com.

METRIC CONVERSION CHART

TO CONVERT	TO	MULTIPLY BY
Inches	Centimeters	2.54
Centimeters	Inches	0.4
Feet	Centimeters	30.5
Centimeters	Feet	0.03
Yards	Meters	0.9
Meters	Yards	1.1

*This book is dedicated to my brother, John—a lovely, gentle man and a great travel buddy—
and to my sister, Anne, a warm and wonderful mother, sister and friend.*

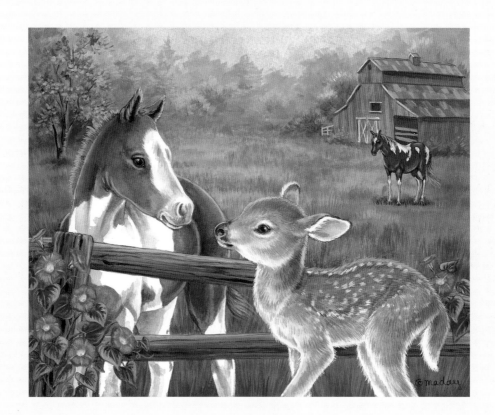

ACKNOWLEDGMENTS

Special thanks to Kathy Kipp and Jackie Musser, my editors for this book, who helped turn a big assignment into one that was fun and exciting. Thanks for guiding me through the whole process!

I also need to extend thanks to Diane at Lakeland Animal Shelter in Elkhorn, Wisconsin, (www.lakelandanimalshelter.org) for her photographic help with dogs and cats. Animal shelters can be a great resource if you need to research a particular breed, and of course they are a great place to find a new companion!

As always, thanks most of all go to my dear husband, John.

contents

PART ONE

Mini Demonstrations

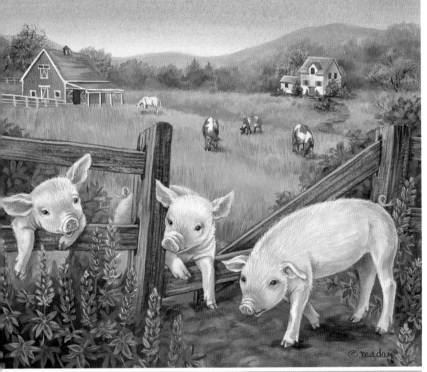

PART TWO

10 Complete Demonstrations

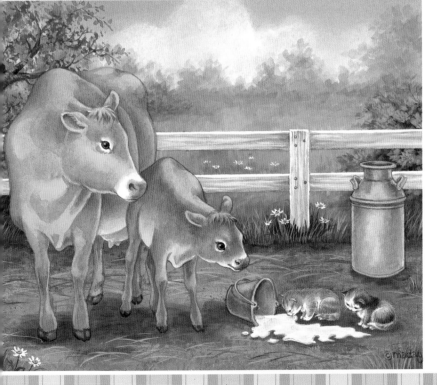

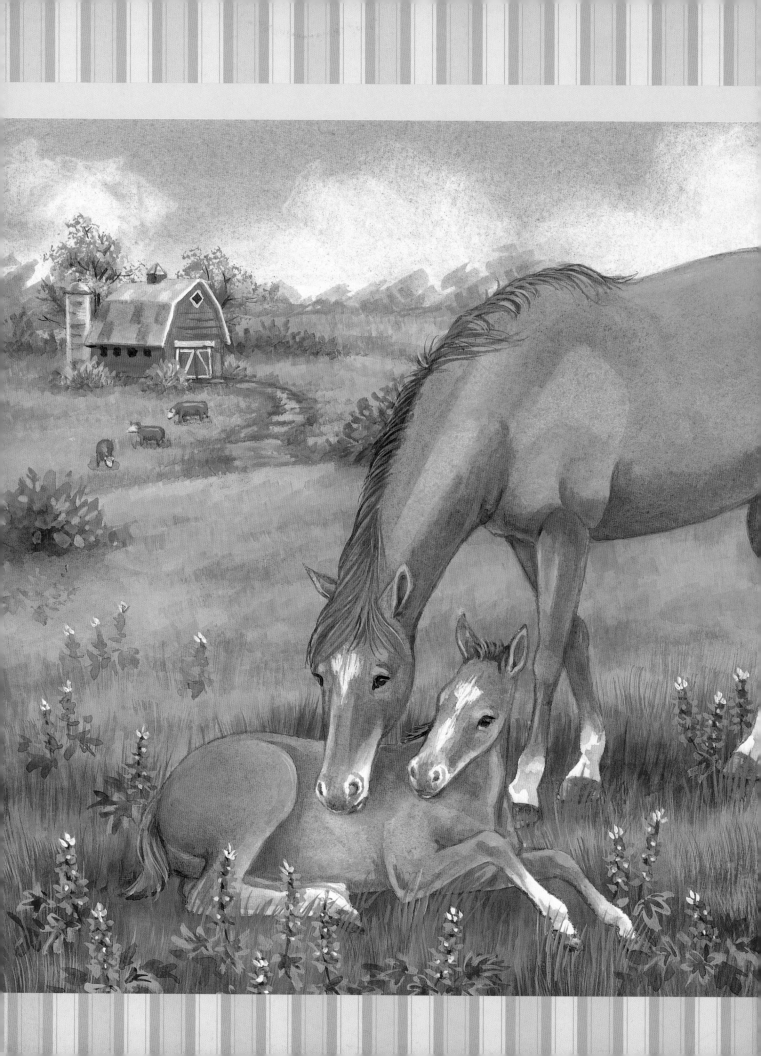

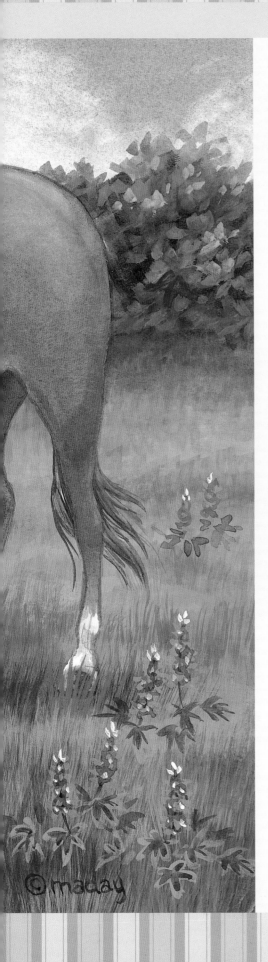

Introduction

LET ME START by thanking you for joining me on a painting journey. Creating art is a lifelong adventure: there is always something new to try, to see, to learn. In this book I have included some of my favorite techniques for creating cute country scenes. I hope you will enjoy painting the projects and then applying the techniques to your own paintings.

I want to point out that there is no right or wrong way to create. Feel free to add your own favorite methods to these projects. Remember, the painting you make is your own, and should reveal your own heart. In these pictures, I've tried to express my feelings for the mother-child relationship, my love for the countryside, and the importance of celebrating our beautiful world. In art, the expression of emotion is just as important as mastering techniques. Don't worry about perfection. If the painting feels good, it is good. I wish you love, luck and happy painting!

Materials

For each project, I have listed my favorite materials; feel free to substitute the brands you like best. However, I do recommend buying the best materials you can afford. When you buy cheap supplies, you end up struggling with dull colors and rough brushes that can hinder your ability to master techniques.

PAPER

For the following projects, I have used Canson Montval acrylic paper. You can also use Canson Montval cold-pressed watercolor paper. I need to mention that if you use masking film, you must use a fairly smooth paper, such as cold-pressed watercolor paper or illustration board, or the paint will bleed underneath the mask. I like using paper that comes in a block rather than using single sheets of paper. (See "Mounting the Paper to Prevent Buckling" at page 13.)

BRUSHES

For the projects in this book, I have used Winsor & Newton Cotman (series 666 and 222) and Galeria brushes. Different types of brushes vary greatly, as you will discover. Buy the highest quality brushes you can afford. Inferior brushes can hinder the abilities of even the most talented artists.

PALETTE

Acrylic paints dry quickly, so I recommend using a wet palette. My favorite is the Masterson Sta-Wet palette. The damp sponge under the paper palette keeps the paints moist for at least a week, even in the dry climate where I live. You can make a substitute with an enamel butcher tray palette. First line it with a pad made from damp, folded paper towels. Soak a sheet of acrylic palette paper in hot water, then place that on the pad. Apply the paints to this surface, and spritz periodically with water from a spray bottle. Cover with plastic cling wrap when finished to keep the paints from drying out.

MASKING FILM AND FLUID

All the projects in this book require the use of either masking film or masking fluid. Since I use the paint transparently, it is sometimes better to protect the white paper in this manner rather than trying to paint over the top of a background color. Masking film comes in sheets or rolls. You'll find it in the airbrush section of craft and art supply stores or online. My favorite brand is Graphix. You may have trouble with paint seepage if you use inferior brands.

To use masking film, you'll also need a sharp craft knife, such as an X-Acto knife with a no. 11 blade. Always start a painting with a new blade in your craft knife. The blade must be sharp enough to cut through the masking film without pressing hard on the knife, or you will score the paper underneath. You may notice that if you dry your painting with a hair dryer it may cause the masking film to bubble slightly. This is nothing to worry about; simply smooth the film with your hand once the paint is dry.

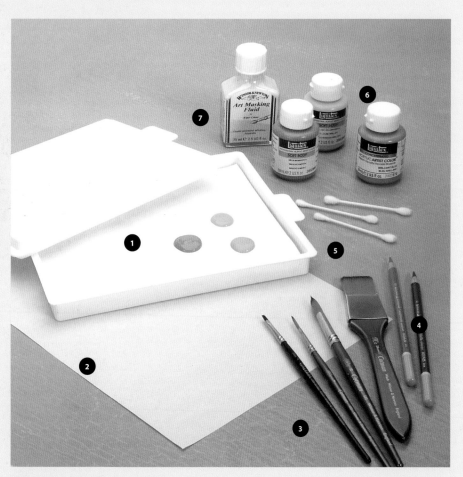

Materials: 1. Wet palette, 2. Tracing paper, 3. Brushes, 4. Pastel pencils, 5. Cotton swabs, 6. Liquitex Soft Body Artist Acrylics, 7. Masking fluid

Masking fluid comes in clear or tinted versions. I like the tinted, as it is easier to see. See "Using Masking Fluid" (page 15) for tips on protecting your brushes, as it is easy to spoil an expensive brush if masking fluid dries in it.

OTHER SUPPLIES

At the beginning of each project, I have listed all the supplies you will need. A few indispensable products are: graphite and white transfer paper; drafting tape (not masking tape!); tracing paper (for copying the patterns); and a sharp pencil with a fairly hard lead, such as 4H. In some projects, I use items such as a sea sponge (for stamping texture), pastel pencils and cotton swabs. You'll also need a water container (for rinsing your brushes), and some nice, thick paper towels (for blotting). Remember, do not eat or drink while you work, and do wash your hands when you're finished.

PAINTS

For this book, I have used Liquitex Soft Body Artist Acrylics, which come in little jars and have a smooth, creamy consistency. I prefer these fluid acrylics to the thicker paints that come in tubes. In the following projects, the paint is almost always diluted with water, as I like to use paints that are quite thin and transparent. As far as colors go, you will notice that many of the color names are followed by the word *Hue*. This indicates a nontoxic form of a color such as the Cadmium colors that in its traditional state may contain toxins like heavy metals. I always try to substitute a nontoxic color wherever possible.

COLOR PALETTE

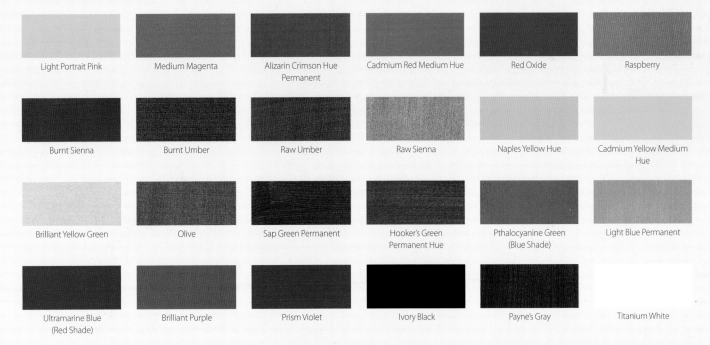

Light Portrait Pink	Medium Magenta	Alizarin Crimson Hue Permanent	Cadmium Red Medium Hue	Red Oxide	Raspberry
Burnt Sienna	Burnt Umber	Raw Umber	Raw Sienna	Naples Yellow Hue	Cadmium Yellow Medium Hue
Brilliant Yellow Green	Olive	Sap Green Permanent	Hooker's Green Permanent Hue	Pthalocyanine Green (Blue Shade)	Light Blue Permanent
Ultramarine Blue (Red Shade)	Brilliant Purple	Prism Violet	Ivory Black	Payne's Gray	Titanium White

Before You Paint

MAKING A RAKE BRUSH

A rake or comb brush is very useful for painting fur and grass. You can purchase one or you can create your own. Store bought versions may be referred to as rakes, grass combs or wisps depending on the manufacturer. I recommend the Golden Natural Grass Comb by Silver Brush and the Royal Soft Grip comb brushes.

1. Start with a flat brush of the size you need.

2. With a small pair of straight scissors, randomly cut notches in the ends of the brush. Make your cuts extend about halfway down the bristles and make sure you leave some of the bristles their original length. The long bristles are the ones that will touch the paper to create a stroke.

3. This is what your brush should look like once the bristles have been cut. When using a rake brush, always use paint that has been diluted or you may end up with clumpy strokes.

USING A WET PALETTE

If you are unfamiliar with acrylics, you may be frustrated by how quickly they dry on a palette. This problem can be solved by using a wet palette, which you can purchase at craft and art supply stores.

A wet palette keeps your acrylics from drying up as you work. The palette has a sponge that you soak before placing it on the palette. Do not wring out the sponge after wetting it.

Next, run or soak the disposable palette paper that comes with it under hot water until it's translucent. Place the wet paper on top of the sponge to use as your palette surface. These palettes also come with an airtight lid that will keep your paints moist for several days.

TRANSFERRING A PATTERN

All the paintings in this book come with patterns that you can trace and transfer to your paper. I use the same method for transferring each time. Transfer paper can be purchased in several colors, as well as in plain graphite.

Use drafting tape to tape the pattern to the paper, because drafting tape will not mar the surface of the paper. Use a mechanical pencil with a very sharp, hard lead (or use a stylus) to transfer the pattern.

Pull back the pattern and transfer paper to make sure the pattern has transferred onto the paper.

MOUNTING THE PAPER TO PREVENT BUCKLING

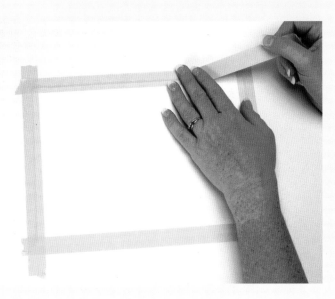

I prefer to paint on cold-pressed watercolor paper or Strathmore 500 series bristol board. This method of mounting works for both types of paper. (The 500 series accepts paint better than other Strathmore bristol board series and is the only type I would recommend.)

I prefer using watercolor paper in a block (a pad that is gummed on all four sides.) If you use single sheets of paper, you should mount them to a board to prevent buckling when the paper gets wet. Use drafting tape, rather than masking tape, because it can be removed without damaging the paper. Choose a backing board that is slightly larger than your paper.

Tape the paper securely on all four sides, so all the edges are covered. If the paper does buckle, wait until the project is completely dry, then remove the paper from the backing board. Flip the paper over and tape it to the backing board again with the image side facing down. Lightly mist the paper with water from a spray bottle. As the paper dries, it should dry flat. Your project should always be completely dry before you remove it from the backing board.

Techniques

APPLYING MASKING FILM

1. Transfer the drawing with transfer paper. With a kneaded eraser, lift any lines that are too dark. Cut a piece of masking film the appropriate size to fit your drawing. Remove the backing as you would from adhesive shelf-lining paper. Lay the masking film over the drawing and smooth out any bubbles.

2. Using a sharp craft knife, carefully cut around the drawing. It is best to use a brand new knife blade so you don't have to push so hard that you score the paper.

3. Peel up the excess masking film from around the drawing and discard. You can paint right over the film.

REMOVING MASKING FILM

1. To remove the masking film after the painted area is dry, lift a corner of the mask with a fingernail or the tip of the craft knife and peel it off.

USING MASKING FLUID

1. Masking fluid can ruin a brush if you're not careful. One way to preserve your brush is to dip it into a solution of equal parts water and dish washing liquid. Tap off the excess on the side of the bowl but do not rinse out the brush.

2. Dip the brush into the bottle of masking fluid. Don't allow the masking fluid to go all the way up to the ferrule of the brush, where it could harden and ruin the shape of your brush. If you will be using the masking fluid for an extended period of time, pour a little out into a separate container so you can replace the lid on the bottle and keep it from drying out.

3. Brush the masking fluid onto the area you need to mask. Let dry completely.

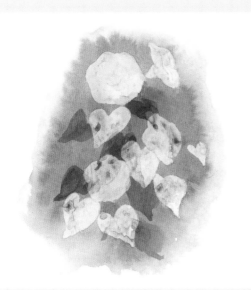

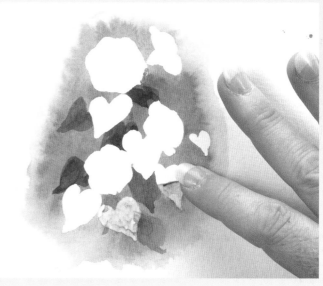

4. Paint your background wash right over the mask.

5. When the paint is dry, remove the mask by rubbing it lightly with a clean finger or a rubber cement pick up.

LOADING THE BRUSH

"Loading the brush" refers to filling your brush with paint.

1. Place a small amount of paint onto the palette. Wet your brush in clean water. When you pull your brush out of the water, gently run the brush tip across a paper towel so it's not dripping wet. Use the brush at the edge of the paint dollop to create a small puddle.

2. Twirl the brush through the paint to create at the end of the brush a fine point that will be retained. Before painting, run the brush tip lightly across a paper towel to remove any excess paint.

1

2

BRUSH MIXING ON A PALETTE

1

2

3

1. Start by pulling out a puddle of the first color with clean water on your brush.

2. Rinse the brush and dip the tip into the second color.

3. Carry the second color and mix it into the puddle of the first color with circular motions of the brush.

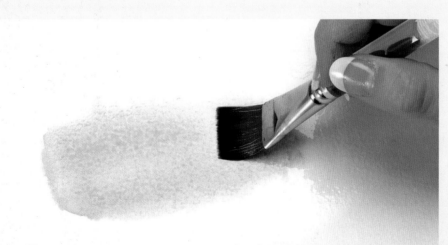

PAINTING A WASH

A "wash" of paint means covering an area with a thin, watery layer of paint. I prefer to use water rather than mediums when painting with acrylics.

Wet the paper with clean water on a brush. Load your brush with the desired paint color and blot the excess on a paper towel. For a vignette background, do not start painting at the edge of the paper. Start painting just inside the wet area so the paint will bleed softly out to the edges. For a flat background, start at the edge and gradually work your way down the page, stroking back and forth with the brush.

USING ACRYLICS LIKE WATERCOLORS

When I paint with acrylics, I like to paint in a watercolor manner most of the time. This gives the finished painting a smooth surface with colors that have depth because I can glaze over them. I use the fluid acrylics that come in bottles because they are thinner than the paint that comes in tubes.

1. Squeeze a blob of color onto a wet palette. Wet a brush with clean water and mix the water into the paint to further thin it. Before painting, test on a piece of scrap paper.

2. You should be able to apply the paint in a transparent manner. To add to the watercolor look and create lighter areas, blend the edges with clean water as you go.

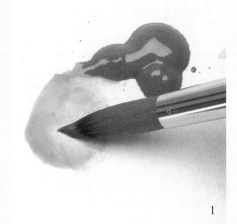

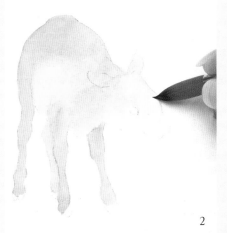

GLAZING

"Glazing" refers to painting a transparent color on top of a color that is already dry. Make sure the first layer of paint is completely dry, or any subsequent layers will "lift" the paint underneath. Use a delicate touch with the brush; do not scrub. Glazing can add to your colors depth that is hard to achieve otherwise.

Photo 1: To glaze, make sure your paint is very transparent; thin the paint with water. Paint a glaze over the area where you want to add just a tint of color. Soften the edges of the glazing with clean water if desired.

Photo 2: Glaze thinned Medium Magenta around the flower centers with a no. 4 round to add depth of color and liveliness to the flowers.

Photo 3: Glazing can add age to textured surfaces such as old wooden fences. Here, I glazed Olive + Hooker's Green Permanent Hue (1:1) on the shaded side of the fence post to show mossiness.

Photo 4: Glazing over an animal's hide adds warmth and softness to the fur. This is especially good for animals with short fur, such as cows and horses.

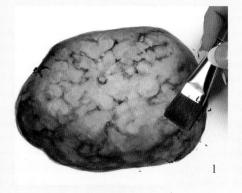

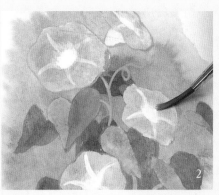

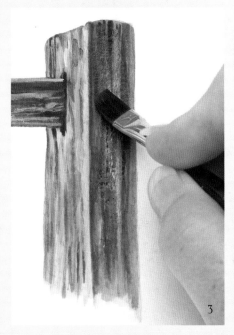

SHADING

1. Objects without shading can appear flat and one-dimensional.

2. Shading under the eaves shows that the roof overhangs the barn. Shading the ground around the base of the barn anchors the barn to the ground. Shading the lower section of the roof emphasizes the different angles of the roof.

PAINTING WITH A SPONGE

Using a sponge is a simple and effective way to add texture to a painting. I like to use them to paint foliage.

1. Brush mix Hooker's Green Permanent Hue + Brilliant Yellow Green (1:1) on your palette. Check a natural sea sponge first to see which side has the shape and texture most appropriate for the object you are painting, then slightly dampen the sponge and dip it into the paint puddle. Test first on a piece of scrap paper to make sure there is not too much paint on it. Stamp the first clusters of leaves.

2. Rinse out the sponge and squeeze out the excess water. Brush mix Titanium White into the green mixture from step 1. Stamp less of this new mixture than the first, and don't stamp too much. Make sure plenty of background shows through to give the leaves an airy, open appearance.

3. Basecoat the branch with Raw Umber on a round brush. Use a smaller brush for the thinnest twigs. Shade the branch with Raw Umber + Payne's Gray (1:1) and highlight it with Titanium White + a touch of Raw Umber. Use the brush and the lighter green mixture from step 2 to paint a few leaves overlapping the branch.

STIPPLING

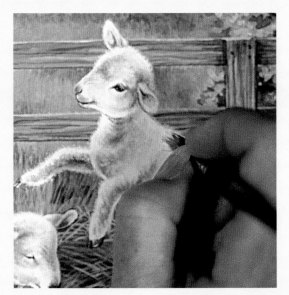

"Stippling" is painting with a series of little dots. In this book, I use the stippling technique to paint a lamb's fleece.

Use any worn-out round bristle brush or a brush made specifically for stippling. A dry blending brush is shown in the photo at left. Load the brush by patting the tip up and down in the paint. Test the brush tip on a paper towel to make sure there is no excess paint. Hold the brush vertically and pat the paint onto the paper.

USING A COTTON SWAB

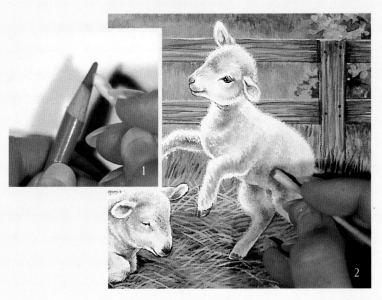

Occasionally I like to add some soft pastel pigment using a cotton swab as a brush. This can give a softer look when adding a little warmth to the inside of an ear or to the fleece of a lamb. This is an optional technique, but I thought you might like to give it a try.

1. Rub the cotton swab over the tip of the pastel pencil to pick up the pigment.

2. Rub the pigment on the tip of the swab onto the paper. This creates a softer smudge of color as compared to using paint.

PAINTING FUR OR GRASS

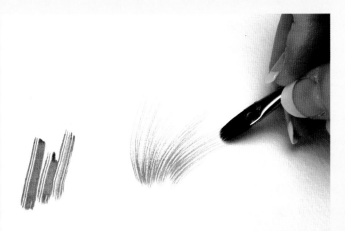

As this book is about painting animals, it is important to practice making fur strokes before you tackle any of the projects.

After loading a filbert grass comb brush, check to make sure the paint is not so thick that the bristles are stuck together. Test on a piece of scrap paper before painting on your project. The strokes on the left are too thick and too straight. The strokes on the right are fluid and tapered, which is the best way to create fur. Remember that the strokes should always follow the direction of fur growth. On page 21, the directions tell you to paint *opaque layers*. This refers to the *paint* being opaque rather than transparent and thin.

Painting Fur and Feathers

SPOTTED FUR

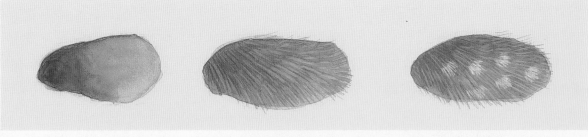

1. Basecoat and shade with thin glazes.

2. Add fur strokes with a grass comb/rake brush.

3. Add midtone hairs and white spots with a small round brush.

PIGSKIN

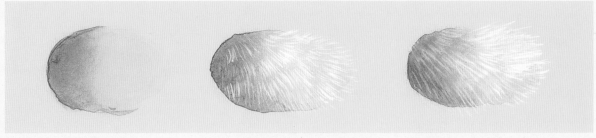

1. Basecoat and add form with shading.

2. Add sparse white hairs, but allow the basecoat to show through.

3. Paint thin glazes over the white hairs.

DUCK FEATHERS

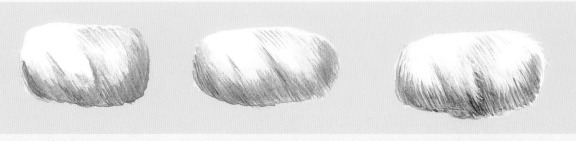

1. Begin developing feathers with Raw Umber.

2. Add warm glazes over the top.

3. Paint white feather details.

HEN FEATHERS

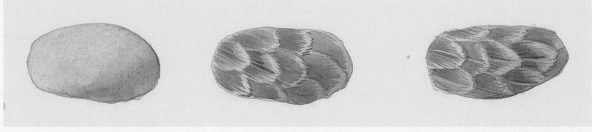

1. Basecoat and glaze shading.

2. Create overlapping feathers.

3. Add light details with a small round brush.

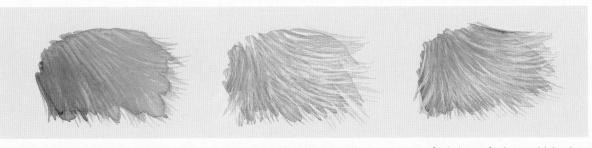

LONG FUR

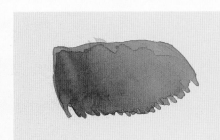

1. Start with a basecoat and shading to add form.

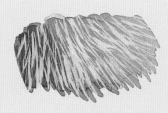

2. Add an opaque fur layer. Fur strokes should taper at the end.

3. Use final glazes of color to add depth.

SHORT FUR

1. Basecoat and establish shading.

2. Add an opaque fur layer. Use short, overlapping strokes.

3. Add a few final glazes and longer, lighter guard hairs.

FLEECE

1. Create form and shape with washes.

2. Apply white paint with a pouncing motion. Hold your brush vertically.

3. Add very soft and thin final glazes using circular strokes.

DOWNY FEATHERS

1. Begin with a basecoat.

2. Create an opaque layer with a round brush and a combination of thick and thin strokes.

3. Add delicate details and glazes with a small round brush.

Mini Demonstrations

FIELDS AND DISTANT GRASS

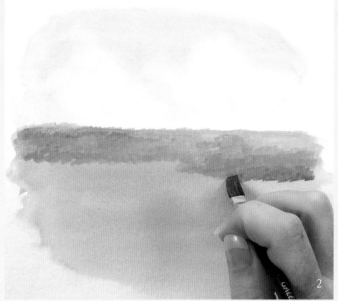

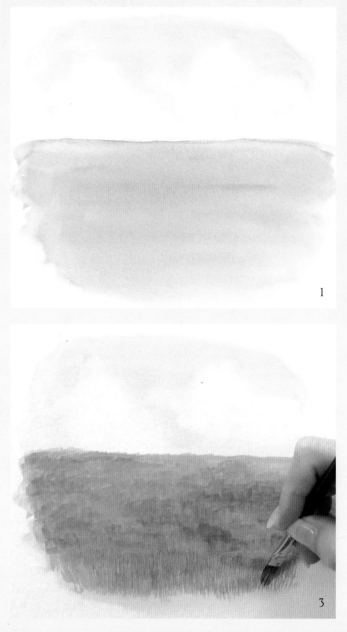

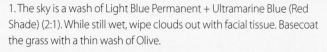

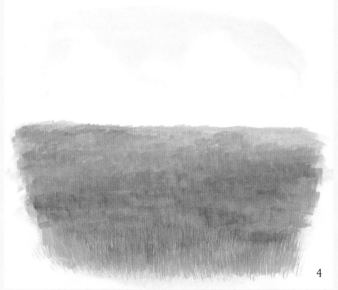

1. The sky is a wash of Light Blue Permanent + Ultramarine Blue (Red Shade) (2:1). While still wet, wipe clouds out with facial tissue. Basecoat the grass with a thin wash of Olive.

2. Brush mix various greens with Naples Yellow Hue + Hooker's Green Permanent Hue or Naples Yellow Hue + Sap Green Permanent. With short downward strokes using a ¼-inch (6mm) flat, start laying in the grass. To create distance, add Titanium White to the mixes closest to the horizon, since colors appear lighter as they recede.

3. For the foreground grass switch to a ¼-inch (6mm) grass comb/rake brush. Add Brilliant Yellow Green to your mixes. Paint with upward strokes so the grasses taper at the ends. If you are more comfortable stroking downward, turn your painting upside down.

4. As a final detail, blend any areas that look blotchy by going back over the surface of the painting.

SKY

1. Wet the paper with clean water and a 1-inch (25mm) flat. While the paper is still wet, paint a wash of Light Blue Permanent + Ultramarine Blue (Red Shade) (2:1).

2. Before the paint dries, wipe the clouds out with facial tissue. Make sure the cloud shapes are irregular.

3. To add a blush of dawn or dusk color, mix Light Portrait Pink + a touch of Naples Yellow Hue and dilute with water until very thin. Using a circular motion, add delicate washes of color to the edges of the clouds with a no. 12 round. Blend the edges with clean water. Add touches of Titanium White to the centers of the pink areas in the clouds. Paint only the side of each cloud that reflects the direction of the sunlight.

TIP

It's better to work in several thin layers to achieve the color intensity you want than to work in one thick layer.

3

STRAW

1. Basecoat with Raw Umber + Payne's Gray (2:1). Mix Raw Sienna + a touch of Titanium White and begin painting straw with a no. 4 round. Vary the curve of your strokes, and make sure some overlap.

2. When that is dry, paint more straw with Naples Yellow Hue and then Naples Yellow Hue + Titanium White (1:1), still using the no. 4 round. Let dry.

3. Add a little greenish straw with a mix of Naples Yellow Hue + Hooker's Green Permanent Hue (1:1). Glaze shading with Raw Umber to show low places in the straw.

PATHS

1. Mix several greens using Hooker's Green Permanent Hue, Naples Yellow Hue and Titanium White and paint the grass with short vertical strokes of a ⅛-inch (3mm) flat. Let dry. Basecoat the path with a thin wash of Raw Umber on a ¼-inch (6mm) flat.

2. Mix several tints of Titanium White and Raw Sienna and paint the path with curved horizontal strokes of a ⅛-inch (3mm) flat. For proper perspective, make sure the path is wider and the details are more clear in the foreground. Add more Raw Sienna to your mixes as the path recedes. Let dry.

3. Glaze shading on the path with a mix of Raw Umber + a touch of Ultramarine Blue (Red Shade). Add texture to the path by using scribbling motions as you shade. If necessary, touch up the grass along the side of the path so that it overlaps the edges slightly.

4. In the foreground, add more Titanium White to the brown mixes to add highlights. Let dry, then glaze very thin Raw Umber over the path only.

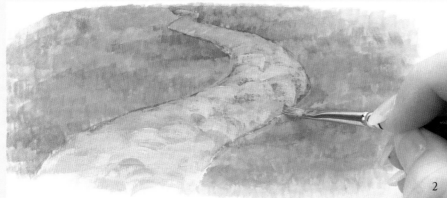

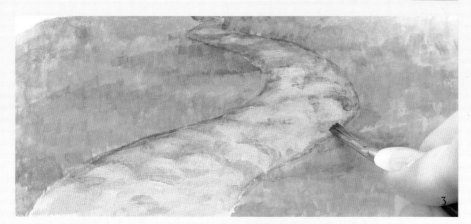

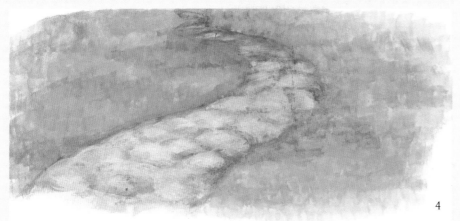

STONE WALLS AND WOODEN FENCES

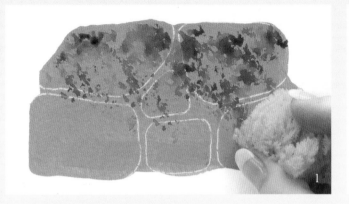

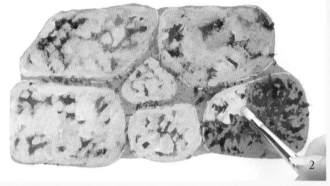

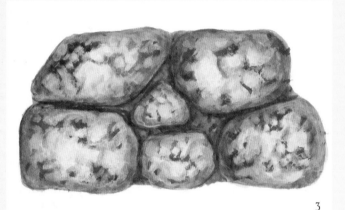

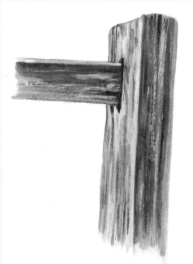

1. Basecoat the wall with Raw Umber + Payne's Gray + Titanium White (1:1:1). Let dry. Transfer the stone lines with white transfer paper. With a damp sea sponge, stamp some texture on the stones with Raw Umber + a generous touch of Ultramarine Blue (Red Shade). Don't worry about stamping over the transfer lines. Let dry.

2. With a ⅛-inch (3mm) flat, mix Titanium White + Raw Umber + Naples Yellow Hue (2:1:1) and paint the light texture on the stones, using the dark stamped areas as a guide. Let dry.

3. Switch to a no. 4 round and glaze shading on the stones with Raw Umber + Payne's Gray (1:1). Create highlights by adding more Titanium White to the mixture from step 2. Then delineate between the stones using a thicker consistency of the shading mix.

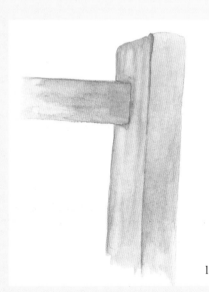

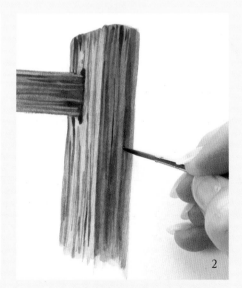

1. Mix Raw Umber + Payne's Gray (1:1) and dilute with water until quite thin. Using a no. 4 round, basecoat the fence one section at a time, letting each dry before you paint the section touching it.

2. Shade the fence with more glazes of the same mix. Switch to a no. 2 round, and add more Payne's Gray to the mixture to paint the wood grain. Use the paint slightly thicker so it is darker. Let dry.

3. Drybrush texture and highlights with Titanium White added to the basecoat color. If the wood looks too light, glaze over it with Raw Umber.

RED BARNS

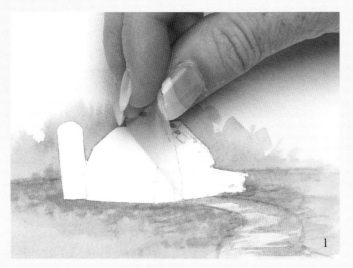

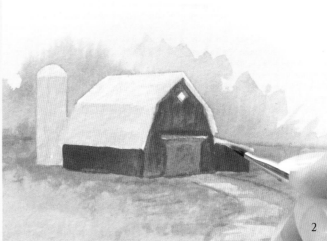

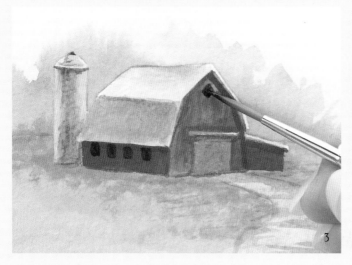

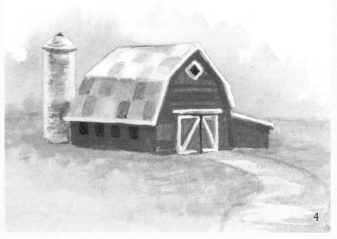

1. Apply masking film to the barn area. Paint a wash for the sky with Light Blue Permanent + Ultramarine Blue (Red Shade) (2:1). While the sky is still wet, lay in the background trees with Hooker's Green Permanent Hue + a slight touch of Ultramarine Blue.

When that is dry, paint the grass with various mixes of Hooker's Green Permanent Hue + a touch of Naples Yellow Hue. Paint the path with a wash of Raw Umber. Remove the masking film when the paint is dry.

2. Basecoat the sides of the barn with Red Oxide + a touch of Titanium White with a ⅛-inch (3mm) flat. Basecoat the roof and silo with Titanium White + a generous touch of Raw Umber.

3. With a no. 2 round, shade the barn's siding by adding Raw Umber to the Red Oxide mixture. Shade the roof and silo by adding more Raw Umber and a touch of Payne's Gray to their basecoat mixture. Add the windows with Raw Umber + a touch of Payne's Gray.

4. Add the white details with Titanium White. Add details to the door and curved horizontal lines to the silo with Raw Umber + a touch of Payne's Gray. Add light shingles to the roof with Titanium White and dark shingles with Raw Umber. Highlight the silo with a little Titanium White. Add a few horizontal Red Oxide lines to the front of the barn.

DISTANT ANIMALS

For all of the demos on pages 28 and 29, wet the background with clean water first, then paint a wash with brush mixtures of Hooker's Green Permanent Hue + Naples Yellow Hue or Brilliant Yellow Green. Next, brush mix various greens with combinations of Light Blue Permanent + Brilliant Yellow Green + Titanium White; Hooker's Green Permanent Hue + Titanium White; Hooker's Green Permanent Hue + Naples Yellow; or Hooker's Green Permanent Hue + a touch of Olive. Paint the grass with short vertical strokes of a ¼-inch (6mm) or ⅛-inch (3mm) flat.

DISTANT SHEEP

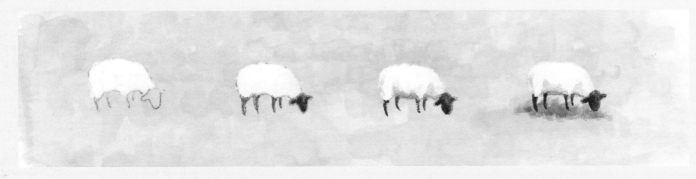

1. Trace and transfer the pattern. Paint the body with Titanium White + a slight touch of Raw Sienna on a no. 2 round, using circular motions with the brush. It may take more than one coat to cover the green background. Let dry between coats.

2. Use a no. 0 round to paint the head and legs with Raw Umber + a touch of Payne's Gray.

3. Shade the sheep with diluted Raw Umber on a no. 2 round.

4. Put a shadow under the sheep with Hooker's Green Permanent Hue + a touch of Raw Umber and short vertical strokes of a ⅛-inch (3mm) flat. This shadow helps anchor the sheep to the ground.

DISTANT HORSE

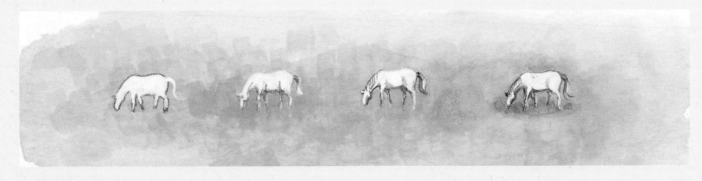

1. Trace and transfer the pattern. Basecoat the horse with Titanium White on a no. 2 round. If you prefer, you may use a no. 0 brush for the tail. It may take more than one coat to cover the green background. Let dry between coats.

2. Shade the horse with diluted Raw Umber on a no. 0 round.

3. Add details with Raw Umber + Payne's Gray (1:1) on a no. 0 round.

4. Shade under the horse with Hooker's Green Permanent Hue + Raw Umber to help anchor the animal to the ground.

DISTANT COW

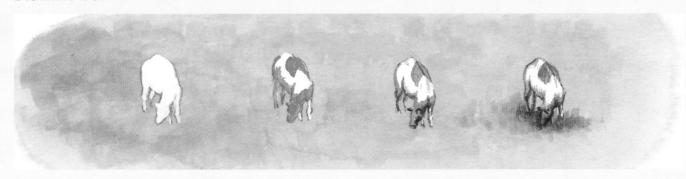

1. Trace and transfer the pattern. Basecoat with Titanium White on a no. 2 round. It may take more than one coat to cover the green background. Let dry between coats.

2. Paint the brown patches on the cow with Burnt Umber + Titanium White (2:1) on a no. 0 round.

3. Shade the cow with Raw Umber on a no. 0 round.

4. With a ⅛-inch (3mm) flat, shade the ground under the cow with Hooker's Green Permanent Hue + a touch of Raw Umber to anchor the cow to the ground.

DISTANT CHICKEN

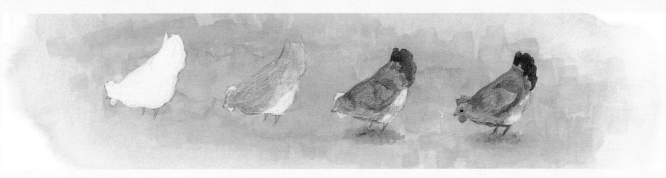

1. Trace and transfer the pattern. Mix Titanium White + Raw Sienna (2:1) and basecoat the hen with a no. 2 round.

2. Paint the brown areas of the hens with Raw Sienna as shown, still using the no. 2 round.

3. Shade the hen with glazes of Raw Umber and a no. 0 round brush. Shade under the hen with Olive and the ⅛-inch (3mm) flat.

4. Paint the comb, wattle, and eye area with Cadmium Red Medium Hue + a touch of Naples Yellow Hue, using the no. 0 round. Use Raw Umber for the legs and eyes.

MOUNTAINS

1. Protect the mountain with masking film or fluid. Wet the sky area with clean water and a 1-inch (25mm) flat. Wash in the blue sky with Light Blue Permanent + Ultramarine Blue (Red Shade) (2:1), and wipe out the white clouds with a tissue (see page 23). Let dry.

2 . Remove the masking film from the mountain area. Mix Burnt Umber + Payne's Gray (2:1), thin the mixture with water, and basecoat the mountain using a ½-inch (13mm) flat. For the green field below the mountain, paint a wash of Hooker's Green Permanent Hue using the dirty brush and blending up into the rocky base of the mountain.

3. Mix Titanium White + Raw Umber (2:1) and tap in textured planes and shapes on the mountainside using the chisel edge of a ¼-inch (6mm) flat. With the Burnt Umber + Payne's Gray basecoat mixture used in step 2, shade the areas of the mountain that are in shadow. The shaded areas are always on the same side, opposite the direction of the sun. In this case the sun is to the left, so the right sides of the planes and shapes of the mountain are in shadow.

4. Brush mix Hooker's Green Permanent Hue + Titanium White + Raw Umber and softly blend into the tree line area at the base of the mountain. Glaze thinned Raw Umber over the mountainside using short strokes and following the individual shapes and contours of the mountain. Load a ¼-inch (6mm) flat with Titanium White and use dabbing motions to add areas of snow in the valleys of the higher elevations.

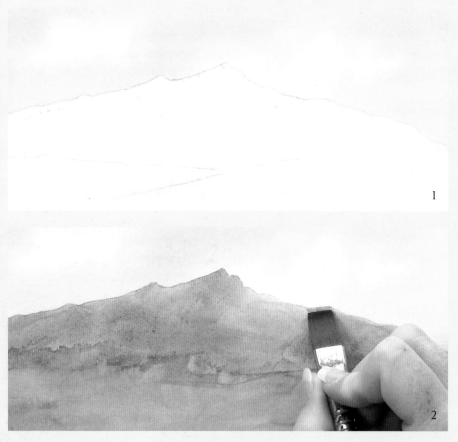

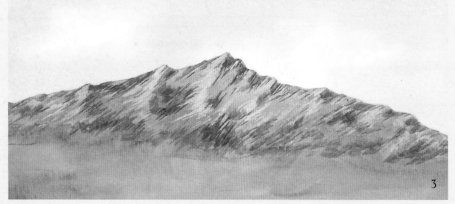

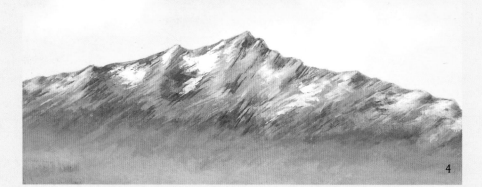

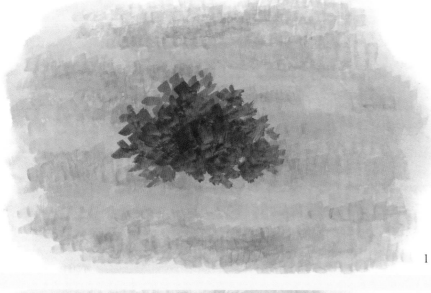

BUSHES

1. Paint the grass with various mixtures of green and yellow. With the ⅛-inch (3mm) flat, paint the bush with Ultramarine Blue (Red Shade) + Hooker's Green Permanent Hue (2:1), using loose and varied brushstrokes in different directions. Make sure the outer edges of the bush are not solid.

2. Brush mix several light greens with Titanium White, Hooker's Green Permanent Hue and Naples Yellow Hue in varying amounts. Start with the midvalue greens and begin painting foliage with back-and-forth strokes of a ⅛-inch (3mm) flat. Make sure some of the dark green of the first layer shows through to add depth.

3. With your lightest green mixtures, add lighter leaves to the bush in some areas to highlight where the sunlight is strongest. When dry, add glazes of a little thinned Raw Sienna and thinned Hooker's Green Permanent Hue over some areas to warm up the colors and make the bush look a little more natural. Glaze a shadow under the bush with the Ultramarine Blue + Hooker's Green Permanent Hue mixture you used in step 1.

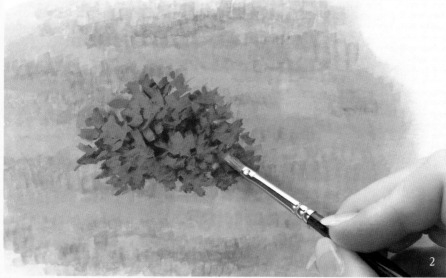

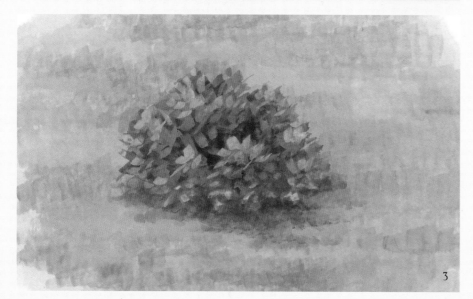

DISTANT TREES

1. Wet the tree line with clean water. Paint a wash of Olive + Hooker's Green Permanent Hue (1:1) with a ¼-inch (6mm) flat, letting the edges bleed into the wet area. Drop in Raw Umber along the tree line while still damp. Let dry. Wet the ground area with clean water. Wash in Hooker's Green Permanent Hue + Brilliant Yellow Green (2:1). Add a touch of Naples Yellow Hue at the horizon.

2. Mix a medium green from Hooker's Green Permanent Hue + Titanium White (2:1). With a ⅛-inch (3mm) flat, begin painting loose tree shapes using short dabbing strokes. Create darker greens by adding a touch of Ultramarine Blue (Red Shade) to your medium green, and dab in shaded areas along the horizon line where the ground meets the distant trees.

3. Add glazes of thinned Red Oxide and thinned Naples Yellow Hue in a few areas to give color variations to the leaves. With the chisel edge of the ⅛-inch (3mm) flat, detail the treetops with individual branches, using the darker green you used in step 2.

1

2

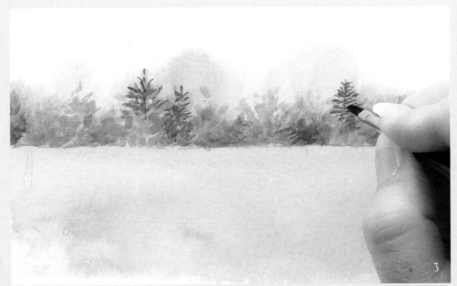

3

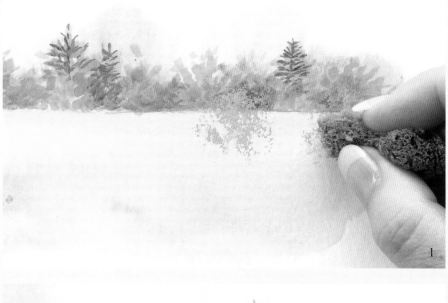

MIDGROUND TREES

1. With a small piece of damp sea sponge, stamp tree shapes with Naples Yellow Hue.

2. Load a ⅛-inch (3mm) flat with Raw Sienna and tap in a few darker leaves. Sponge on a few very light leaves with Cadmium Yellow Medium Hue brush mixed with Titanium White. Paint the branches with Raw Umber on a no. 1 round. Add shadows under the trees and soften the horizon line with a medium green mixed from Hooker's Green Permanent Hue + Raw Umber (2:1) on a ⅛-inch (3mm) flat.

3. To paint midground trees with a brush, use a ⅛-inch (3mm) flat. Paint medium green foliage with a mixture of Naples Yellow Hue and Hooker's Green Permanent Hue (1:1) diluted with water to a milky consistency. Add a touch of Ultramarine Blue (Red Shade) for darker leaves. Keep the leaves airy and open. Add a few patches of Raw Sienna foliage. For the lightest highlight leaves, use Brilliant Yellow Green + Titanium White (1:1). Finish with branches of Raw Umber + a touch of Payne's Gray on a no. 1 round.

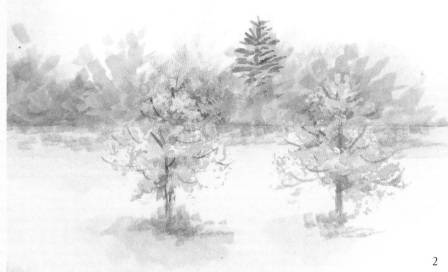

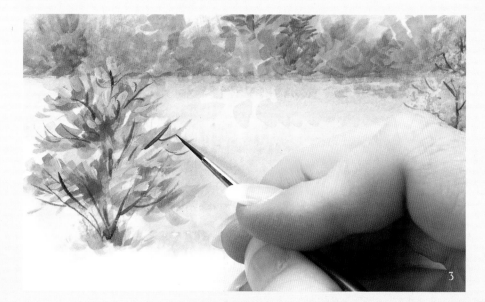

BIRCH BARK

1. Basecoat the birch tree trunk with a no. 4 round loaded with Raw Umber + a generous touch of Titanium White. Use the chisel edge of a ¼-inch (6mm) flat to paint in the branches using the same colors. Paint the trunk with curved horizontal strokes of Titanium White on a ¼-inch (6mm) flat to show the bark texture.

2. Load a ⅛-inch (3mm) flat with thinned Payne's Gray, and glaze shading along the outer edges of the trunk and branches to show roundness.

3. Using a no. 1 round, glaze a little thinned Naples Yellow Hue to the right of the center to add sunshiny warmth to the bark. Mix Burnt Umber + Ultramarine Blue (Red Shade) (1:1), thin with water, and paint the curved horizontal lines that show cracks in the bark where it will peel.

4. Load a no. 1 round with Burnt Umber + Ultramarine Blue full strength, and paint the eye-shaped knotholes in the bark where branches have broken off.

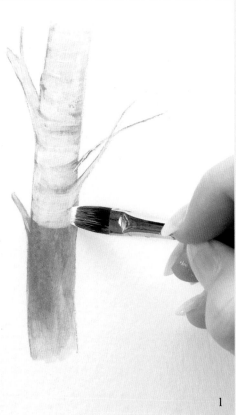

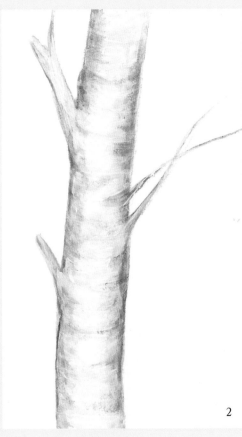

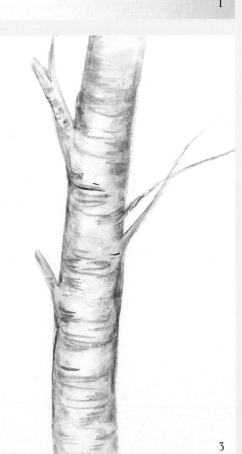

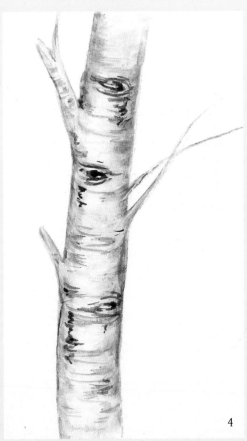

FLOWERING TREES

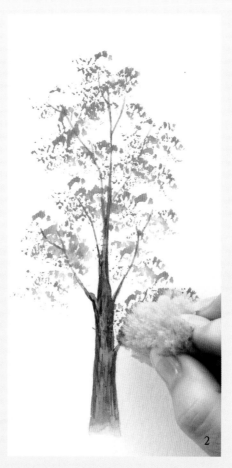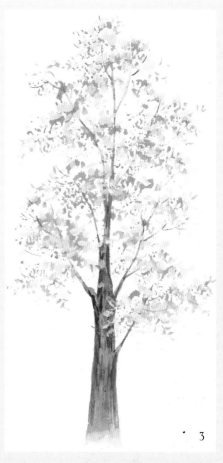

1. Basecoat the tree trunk and branches with Burnt Umber + a touch of Ultramarine Blue (Red Shade) on a no. 4 round. Switch to a smaller brush for the thinnest branches if desired. Add a little more Ultramarine Blue to the basecoat mixture and shade the trunk and branches using a no. 2 round. Add a little Titanium White to the basecoat mixture and highlight the trunks and branches. Let dry, then glaze with a little thinned Raw Umber.

2. Use a small piece of slightly damp sea sponge to stamp the darker pink flowers with Medium Magenta. Don't overdo it—leave the blossoms open and airy.

3. With a ⅛-inch (3mm) flat, brush mix Titanium White + Medium Magenta (2:1) and dab on the lighter pink flowers. Again, don't fill them in completely; leave open spaces. With a no. 0 round, brush mix Brilliant Yellow Green + Hooker's Green Permanent Hue and add some small leaves interspersed along the branches. Add a few more fine twigs here and there with the basecoat mixture used in step 1 and a no. 1 round.

LUPINES

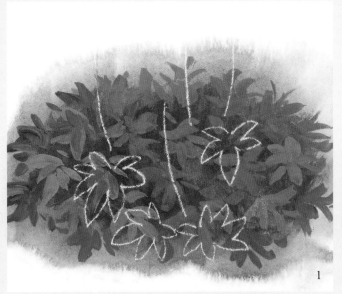

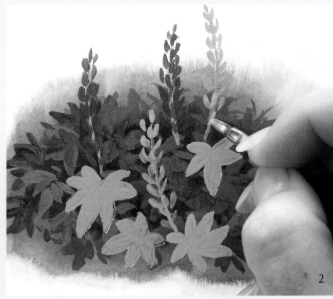

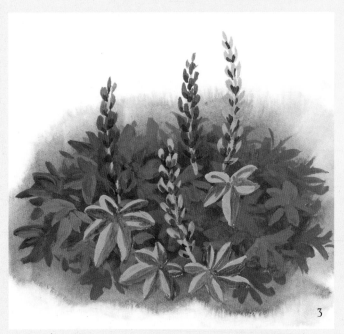

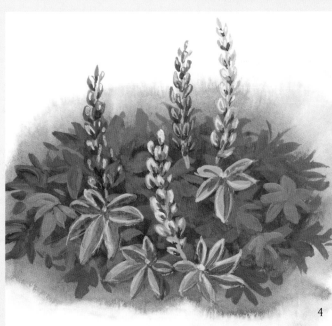

1. Paint a wash of Hooker's Green Permanent Hue + Payne's Gray (2:1). Let dry. Mix various combinations of Hooker's Green Permanent Hue + Titanium White and paint vague leaf shapes with a ⅛-inch (3mm) flat. Let dry, then indicate placement of leaves and stems with a light colored pencil or transfer with white transfer paper.

2. Mix Brilliant Yellow Green + Hooker's Green Permanent Hue + Titanium White (2:1:1) and paint the leaves with the ⅛-inch (3mm) flat. Paint the stems with the chisel edge of the brush. With the same flat, tap in the petals of the dark pink lupines with Raspberry + a touch of Medium Magenta using a light downward stroke. Brush mix Brilliant Purple + Light Blue

Permanent + Titanium White (1:1:a touch) and paint the petals of the blue lupines.

3. Shade the leaves with Hooker's Green Permanent Hue on a no. 2 round. Shade the pink lupines with Alizarin Crimson Hue Permanent. Shade the blue lupines with Ultramarine Blue (Red Shade) + Alizarin Crimson Hue Permanent (2:1).

4. Highlight the flowers with Titanium White using the tip of a no. 2 round. Highlight the leaves with Titanium White + Brilliant Yellow Green (1:1). If the leaves become too bright and compete with the flowers, glaze over them with thinned Hooker's Green Permanent Hue.

MORNING GLORIES

1. Mask the flowers and leaves with masking fluid. When the mask is dry, wet the paper with clean water and a no. 12 round. Paint a wash of Hooker's Green Permanent Hue + Ultramarine Blue (Red Shade) (1:1) starting in the middle and letting it bleed out to the edges. Let dry. Paint loose leaf shapes behind the flowers with the same mixture. Let dry. Remove the mask.

2. Basecoat the flowers with Light Blue Permanent + a touch of Medium Magenta on a no. 4 round. Basecoat the leaves with Brilliant Yellow Green + Hooker's Green Permanent Hue (2:1). Let dry.

3. Still using the no. 4 round, paint the centers of the blue flowers with Titanium White, and pull white lines radiating outward for the ribs. Shade the leaves with Hooker's Green Permanent Hue + Ultramarine Blue (1:1). With a no. 2 round, add a touch of Titanium White to the leaf basecoat mixture from step 2 and paint the stems for the leaves and flowers.

4. Glaze thinned Medium Magenta around the flower centers with a no. 4 round to add depth of color and liveliness to the morning glories. Dot Naples Yellow Hue in the centers of the flowers. Add Ultramarine Blue to the flower basecoat mixture from step 2 and shade the flowers. When shading, blend with clean water while the paint is still wet. Detail the leaves with Hooker's Green Permanent Hue. Highlight the leaves and flowers with Titanium White on a no. 4 round.

1

2

3

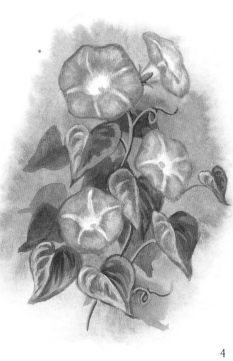

4

VIOLETS

1. Basecoat the leaves with Hooker's Green Permanent Hue + a touch of Titanium White using a no. 4 round. Switch to a no. 2 round for the stems. Basecoat the violet petals with Brilliant Purple + Ultramarine Blue (Red Shade) (2:1) using a no. 4 round. The paint should be thin and washy.

2. Brush mix Hooker's Green Permanent Hue + Ultramarine Blue (1:1) and shade one side of each leaf with a no. 4 round. Dot Payne's Gray in the centers of the flowers. Brush mix Ultramarine Blue + a touch of Payne's Gray and shade the petals of the flowers using a no. 1 round.

3. Add Titanium White to the petal basecoat mixture from step 1 and draw tiny whisker lines on each violet petal using a no. 1 round. Add form to the leaves using the leaf-shading mixture from step 2 on a no. 4 round. Highlight the leaves with Brilliant Yellow Green + a touch of Titanium White.

4. With a no. 1 round, paint around the centers of the violets with tiny lines of Titanium White. Brush-mix Titanium White + Brilliant Yellow Green and paint the veins in the leaves. Add a small dot of Naples Yellow Hue to each flower center.

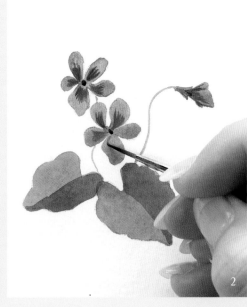

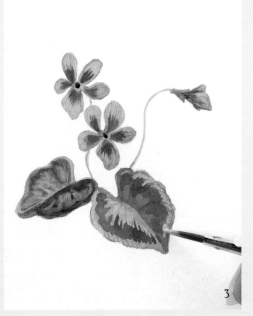

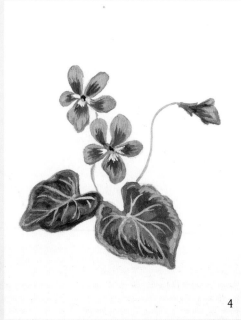

POPPIES, DAISIES AND DELPHINIUMS

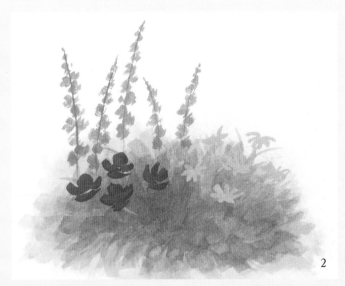

1. Wet the paper with clean water and paint a wash of Olive using a ½-inch (12mm) flat. Let dry. Paint random strokes of Hooker's Green Permanent Hue + Payne's Gray (2:1) with the ¼-inch (6mm) flat. Let dry. Loosely sketch in the placement of the flowers with a pencil.

2. Paint the stems for the blue flowers (delphiniums) with Hooker's Green Permanent Hue + Olive (1:1) using the no. 0 round brush. With the ⅛-inch (3mm) flat, paint the petals with Ultramarine Blue (Red Shade) + a touch of Light Blue Permanent. Basecoat the red poppies with Cadmium Red Medium Hue + a touch of Naples Yellow Hue using curved strokes of a ⅛-inch (3mm) flat. Switch to a no. 2 round to paint the yellow flowers with Naples Yellow Hue + a touch of Titanium White.

3. Add Ultramarine Blue centers to the blue flowers with a no. 1 round. Still using the no. 1 round, paint the centers of the poppies with Payne's

Gray + a touch of Raw Umber. Paint the centers of the yellow flowers Raw Umber. Switch to a no. 2 round and begin painting loose stems and leaves and blades of grass with Hooker's Green Permanent Hue.

4. Highlight the blue flowers with Light Blue Permanent + a touch of Titanium White. Dot Naples Yellow Hue in the center of some flowers with a no. 1 round. Add Titanium White to the red flower mixture from step 2 and paint around the dark centers with a no. 1 round. Mix Cadmium Yellow Medium Hue + a touch of Cadmium Red Medium Hue and glaze the centers of the yellow flowers. Glaze the petals with Cadmium Yellow Medium Hue and add Titanium White highlights. Add lighter leaves with Brilliant Yellow Green + a touch of Titanium White. Glaze a little thinned Hooker's Green Permanent Hue over the foliage to add depth.

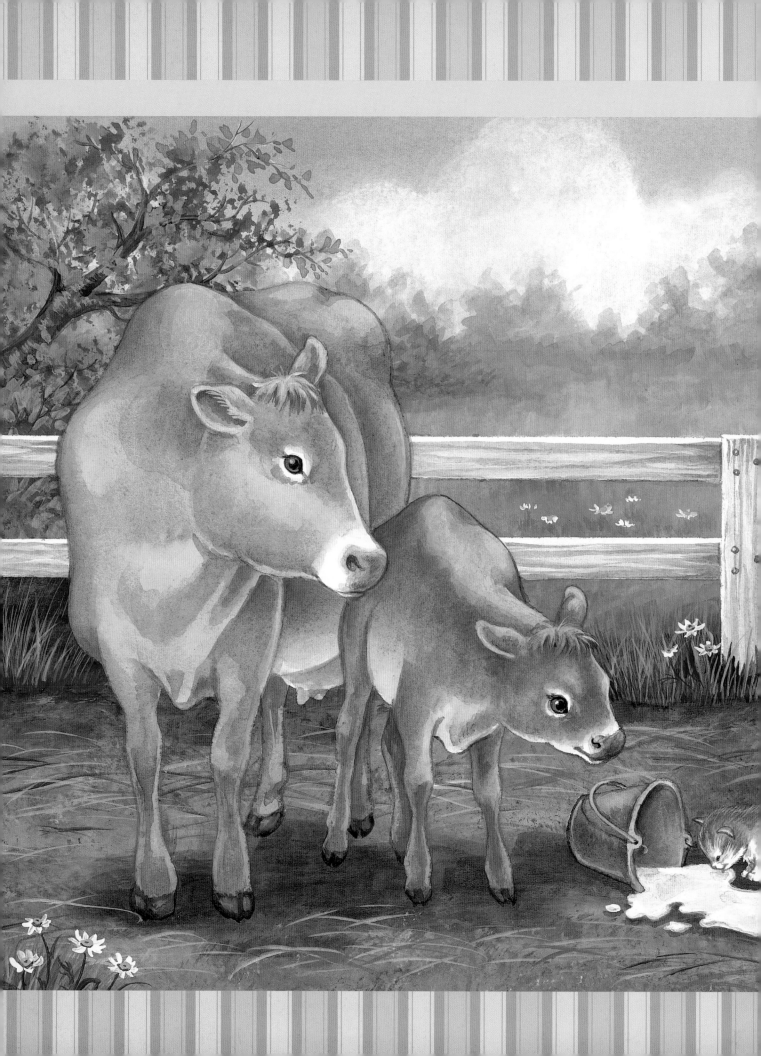

Spilled Milk

SOONER OR LATER, every youngster will knock over his or her milk. In this case, however, two little kittens are on hand to take advantage of this unexpected treat! I chose Jersey cows for this painting because their calves are especially beautiful, with large, expressive eyes.

MATERIALS LIST

Surface
9"× 12" (23cm × 30cm) Canson Montval acrylic paper 148lb. (315gsm)

Brushes
¾-inch (19mm) flat

⅛-inch (3mm) and ¼-inch (6mm) one-stroke flat washes

nos. 1 and 4 rounds

¼-inch (6mm) grass comb/rake (home-made or purchased, see page 12)

Rigger (optional)

Liquitex Artist Soft Body Acrylic Colors
Brilliant Yellow Green, Burnt Umber, Hooker's Green Permanent Hue, Light Blue Permanent, Medium Magenta, Naples Yellow Hue, Olive, Payne's Gray, Raw Sienna, Raw Umber, Titanium White

Additional Materials
Foamcore board

Sharp craft knife

Masking film (or fluid)

Wet palette

Water in a container

Drafting tape (*not* masking tape)

Sharp pencil or stylus

Graphite transfer paper

Tracing paper

Facial tissues

Small sea sponge

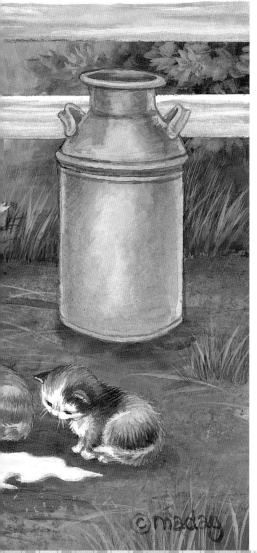

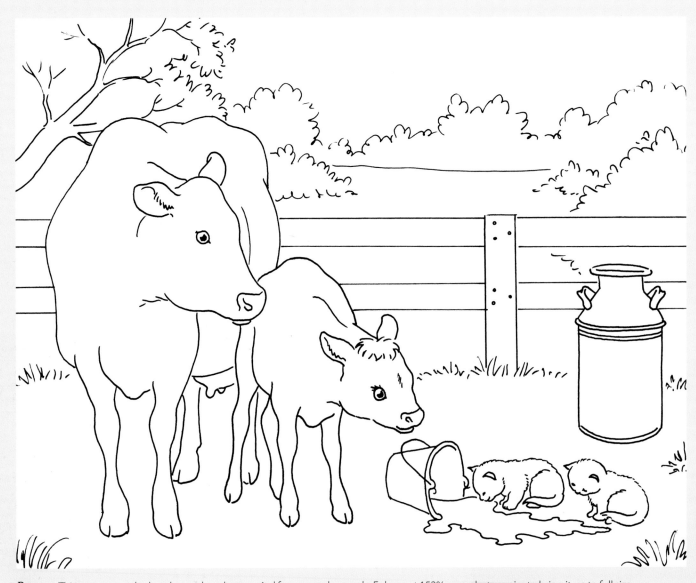

Pattern. This pattern may be hand-traced or photocopied for personal use only. Enlarge at 152% on a photocopier to bring it up to full size.

COLOR MIXTURES

Medium Magenta + Naples Yellow Hue + Titanium White (1: touch: touch)

Raw Umber + Naples Yellow Hue + Titanium White (1:1:1)

Hooker's Green Permanent Hue + Payne's Gray (1:1)

Hooker's Green Permanent Hue + Raw Umber (1:1)

Hooker's Green Permanent Hue + Brilliant Yellow Green (1:1)

Light Blue Permanent + Olive (1:1)

Light Blue Permanent + Medium Magenta (2:1)

PREPARE FOR PAINTING

Use drafting tape to tape the acrylic paper on all four sides to the foam core support. Also, mark off an 8" × 10" (20cm × 25cm) area with the tape. Trace and transfer the design, except for the bushes and branches. Use masking film to protect the fence, cow, calf, milk can, bucket and kittens as instructed on pages 14-15. If you use masking fluid, you will need to reapply it after you uncover the fence in step 9.

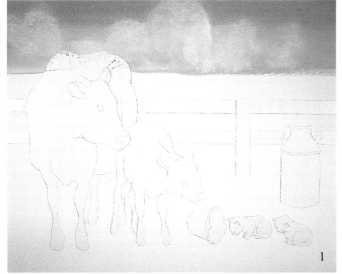

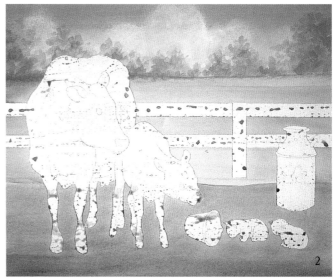

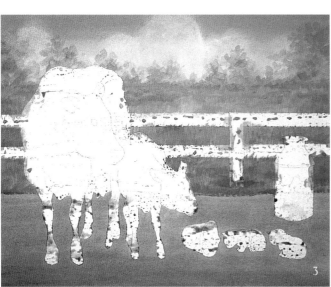

1. Sky and Clouds. Wet the sky area with clean water and the ¾-inch (19mm) flat. Brush mix Light Blue Permanent + Medium Magenta (2:1) and paint the entire sky. While it is still wet, use a facial tissue to wipe out the clouds as shown on page 23. Switch to the ¼-inch (6mm) flat and paint a blush on the clouds with Titanium White + a touch of Medium Magenta.

2. Grass. Basecoat the grass using Olive and the ¾-inch (19mm) flat. For the ground under the cows, use a wash of Raw Umber. Mix Light Blue Permanent + Olive (1:1) and dilute until very transparent. Paint loose tree shapes along the horizon with the ⅛-inch (3mm) flat. Paint a little diluted Olive over the top to add form.

3. Grass. Using the ¼-inch (6mm) flat, begin painting the grass with short, vertical strokes, starting at the horizon. Mix various greens with Olive, Naples Yellow Hue, Light Blue Permanent, and Hooker's Green Permanent Hue. Add touches of Titanium White to the mixtures for the distant grass. Some of the grass is pure Naples Yellow Hue.

4. Foliage. Use the sea sponge to tap in some foliage on the left with a mixture of Hooker's Green Permanent Hue + Brilliant Yellow Green (1:1). Add Titanium White to the mixture for lighter foliage; and for the darker foliage use Olive. Let dry, then transfer the branch. Paint the branch with Raw Umber and the ⅛-inch (3mm) flat. For the little branches, use the chisel edge of the brush or use a rigger brush if you prefer.

5. *Tree Trunk and Bushes*. Mix Raw Umber + Titanium White (1:1) and add form to the tree trunk with the ⅛-inch (3mm) flat. Add more Titanium White to the mixture for the lightest areas. Detail the trunk with Raw Umber. Mix Hooker's Green Permanent Hue + Raw Umber (1:1), dilute with water and lay in a couple of bushes on the right with the ⅛-inch (3mm) flat.

6. *Ground and Foliage Details*. Paint shadows under the bushes with Raw Umber. Add Titanium White to the grass mixtures from step 3 and paint lighter foliage on the bushes with the ⅛-inch (3mm) flat. Add leaves that overlap the branch. Add delicate twigs with Raw Umber and the no. 1 round. For the blossoms on the bush, use Medium Magenta + Titanium White (1:1), with darker touches of Medium Magenta.

7. *Foreground*. Mix Raw Umber + Naples Yellow Hue + Titanium White (1:1:1) and paint the foreground with loose, horizontal strokes of the ¼-inch (6mm) flat. For shadows use glazes of Raw Umber + a touch of Payne's Gray. Paint the area under the fence with a mixture of Hooker's Green Permanent Hue + Payne's Gray (1:1).

8. *Foreground*. On the ground beneath the cows, pat in texture with the sea sponge with Raw Umber. Paint grass strokes with the grass comb/rake ¼-inch (6mm) and the light green mixtures from step 3. Add some individual grass blades of Naples Yellow Hue and Brilliant Yellow Green with the no. 1 round.

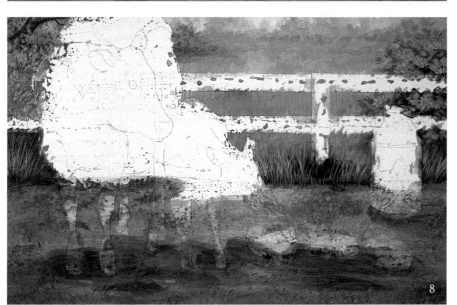

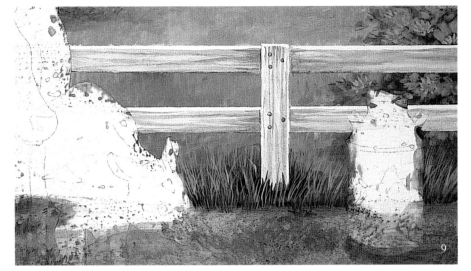

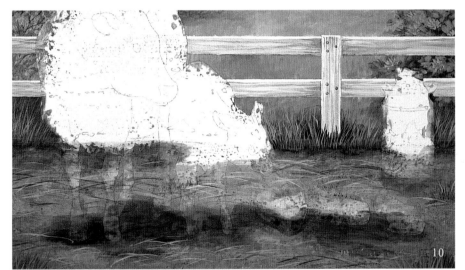

9. Fence. Remove the masking film from the fence (see page 14). Brush mix Raw Umber + a touch of Payne's Gray and dilute with water until it is very transparent. Paint the fence boards with the ¼-inch (6mm) flat, leaving a strip of white paper along the top. Paint streaks of Titanium White to add texture. Add dots of Raw Umber for nails with the no. 1 round. Use the no. 1 round to paint more blades of grass, using varying mixtures of green. Glaze some very thin Brilliant Yellow Green across the distant trees.

10. Foreground. Add some Titanium White to Raw Umber and sponge in some more texture on the ground beneath the cows. When dry, glaze a little more Raw Umber shading under the cows and along the grass line. With the no. 1 round, paint loose pieces of straw using Naples Yellow Hue + touches of Titanium White, Raw Sienna and Olive. Paint some clumps of grass as you did under the fence in step 9.

11. Milk Can and Cow. Remove the mask from the milk can and the cow, being especially careful when uncovering her legs. Touch up with Titanium White if necessary. Using the ¼-inch (6mm) flat, basecoat the milk can with Payne's Gray + a touch of Titanium White, diluted with water until transparent. Use the no. 4 round to basecoat the cow with Raw Sienna + a touch of Titanium White, also diluted with clean water. For the eye, use Burnt Umber. Try to leave the muzzle and the area around the eye as plain white paper. Begin shading the cow with thin glazes of Raw Umber, still using the no. 4 round.

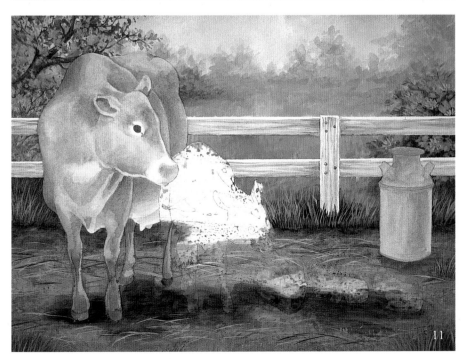

TIPS

- *When painting foliage,* make sure that some background shows through. If a clump of leaves looks too solid it will look unnatural.

- *If your colors look dull,* try glazing over them with Quinacridone/Nickle Azo Gold from Golden Fluid Acrylics.

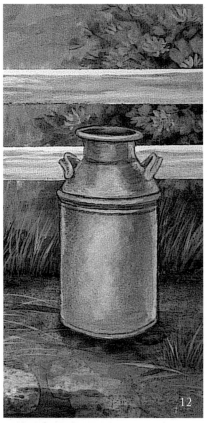

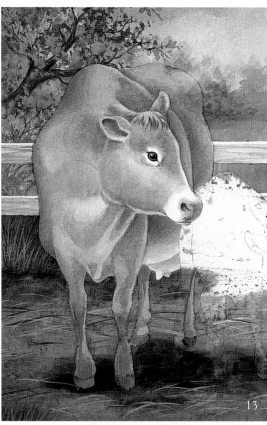

12. Milk Can. Glaze a little Raw Sienna over the left side of the milk can with the no. 4 round. Let dry, then shade with glazes of Payne's Gray. Highlight with Titanium White, blending with clean water while it is still wet. Detail with more Payne's Gray, and add a thin glaze of Olive to the right side.

13. Shade Cow. Glaze more shading on the cow using Burnt Umber and the no. 4 round. Glaze some Raw Sienna over the top. Glaze a little Payne's Gray over the muzzle. Switch to the no. 1 round and detail the nose and eye with less-diluted Payne's Gray. Add a Titanium White highlight to the eye.

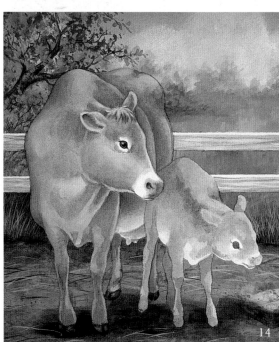

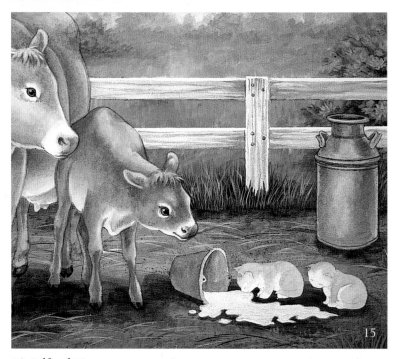

14. Cow and Calf. Highlight the cow with Titanium White + a touch of Raw Sienna. Glaze over the highlights with Raw Sienna, if they look too bright. Detail the hooves with Payne's Gray. Add a little outlining with Raw Sienna. Remove the mask from the calf and basecoat it as you did the cow in step 11. Begin shading with glazes of Raw Umber and the no. 4 round.

15. Calf and Kittens. Finish the calf as you did the cow. Remove the remaining masking film. Basecoat the bucket with thin Payne's Gray on the no. 4 round. Paint the spilled milk with Titanium White. Basecoat the kittens with diluted Raw Sienna, leaving some areas as white paper, as shown.

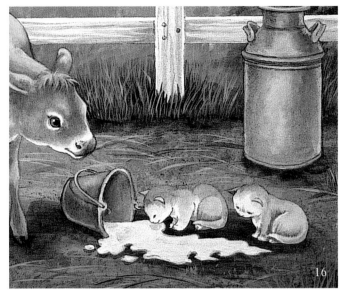

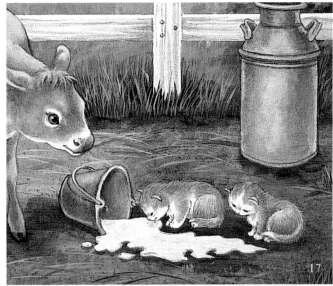

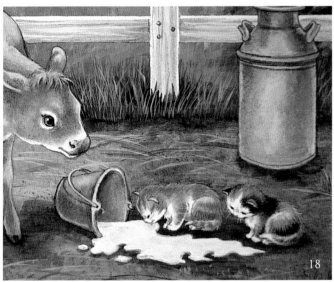

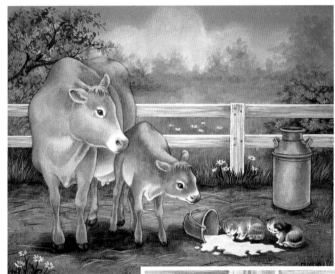

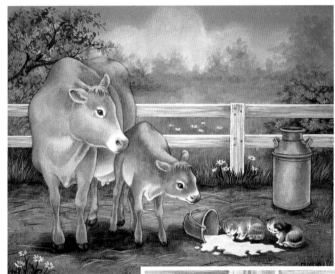

16. Bucket and Kittens. With the no. 1 round, shade the bucket with glazes of Payne's Gray, and highlight with Titanium White. Add rust with glazes of Raw Sienna.

Shade and detail the kittens with thin Raw Umber. Glaze the center of the spilled milk with Naples Yellow Hue + a touch of Titanium White. Paint the edge of the milk with a diluted mixture of Light Blue Permanent + a touch of Payne's Gray.

17. Kittens. Paint fluffy fur on the kittens using the no. 1 round and Titanium White + a touch of Raw Sienna. Add more Raw Sienna fur over the top. Paint the noses and a little pink tongue with a mixture of Medium Magenta + Naples Yellow + Titanium White (1: touch: touch).

18. Kittens. Finish the kittens with the no. 1 round (or a smaller brush, if you prefer). For the calico kitten, add dark fur with Payne's Gray + Burnt Umber (2:1). Add more Raw Sienna if necessary to the orange areas. For the tabby kitty, add stripes with Burnt Umber. Add a few delicate Titanium White whiskers if desired.

19. Daisies and Grass. With the no. 1 round, paint Titanium White daisies around the fence post and the lower-left corner. Give the flowers Hooker's Green Permanent Hue stems and Naples Yellow Hue centers. Add a few more Naples Yellow Hue grasses around them. Detail the centers with Burnt Umber. Add a few more tiny daisies between the fence boards.

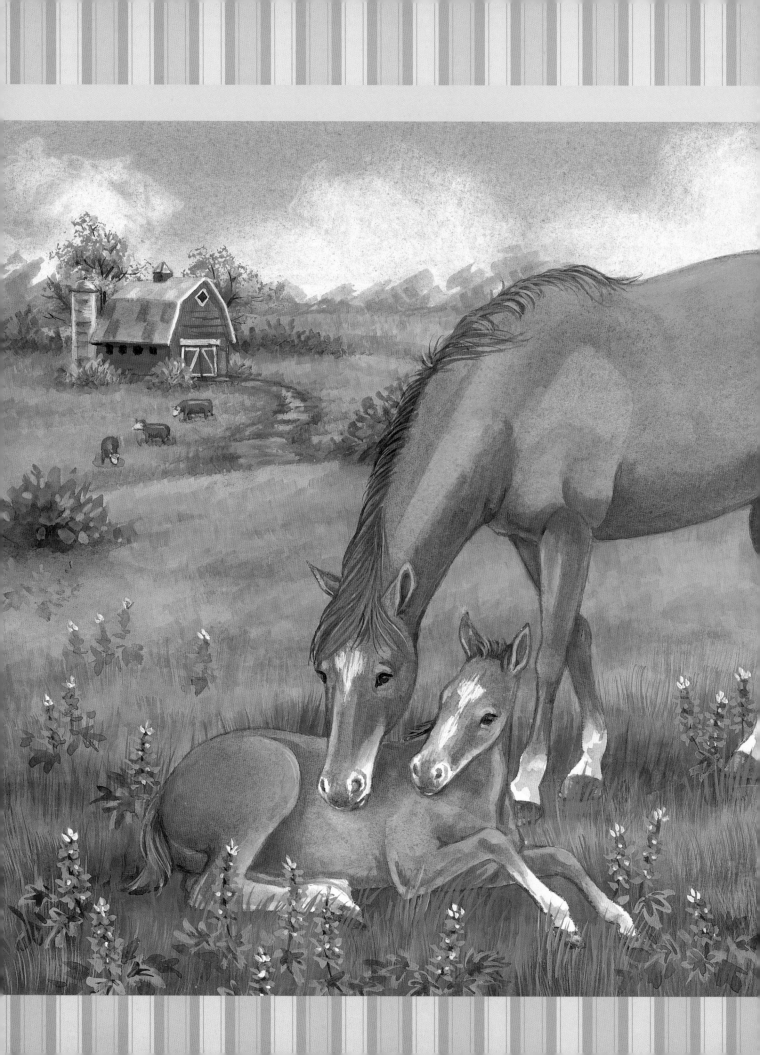

Mother's Love

THIS PAINTING SHOWS the protective feelings a mother has for her baby. There is a horse farm down the road from my house, and I have often noticed the way the mares stay near their foals. While the babies sleep, the mares graze quietly, and they watch protectively while their babies romp and play.

MATERIALS LIST

Surface
9"× 12" (23cm × 30cm) Canson Montval acrylic paper 148lb (315gsm)

Brushes
¾-inch (19mm) and ½-inch (12mm) flats

⅛-inch (3mm) and ¼-inch (6mm) one-stroke flat washes

nos. 1 and 4 rounds

¼-inch (6mm) grass comb/rake brush (homemade or purchased, see page 12)

Liquitex Artist Soft Body Acrylic Colors
Brilliant Yellow Green, Burnt Sienna, Burnt Umber, Hooker's Green Permanent Hue, Light Blue Permanent, Naples Yellow Hue, Raw Sienna, Raw Umber, Red Oxide, Sap Green Permanent, Titanium White, Ultramarine Blue (Red Shade)

Additional Materials
Foamcore board

Sharp craft knife

Masking film or masking fluid

Wet palette

Water in a container

Drafting tape (*not* masking tape)

Sharp pencil or stylus

Graphite transfer paper

Tracing paper

Facial tissues

Small sea sponge

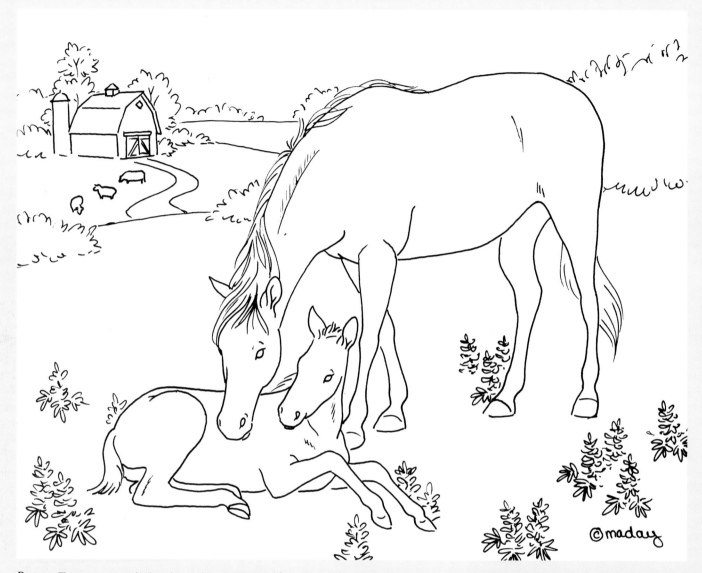

Pattern. This pattern may be hand-traced or photocopied for personal use only. Enlarge at 152% with a photocopier to bring it up to full size.

COLOR MIXTURES

Brilliant Yellow Green + Titanium White + Hooker's Green Permanent Hue (1:1: touch)

Sap Green Permanent + Ultramarine Blue (1:1)

Sap Green Permanent + Ultramarine Blue (2:1)

Hooker's Green Permanent Hue + Ultramarine Blue (2:1)

Light Blue Permanent + Hooker's Green Permanent Hue + Titanium White (2:1:1)

Ultramarine Blue + Light Blue Permanent (3:1)

Ultramarine Blue + Raw Umber (2:1)

PREPARE FOR PAINTING

Use the drafting tape to tape the acrylic paper on all four sides to the foamcore support, leaving an 8" × 10" (20cm × 25cm) area for painting. Trace and transfer the design, except for the bushes, flowers and distant cows. Use either masking film or masking fluid to protect the barn, the horse and the foal as instructed on pages 14-15.

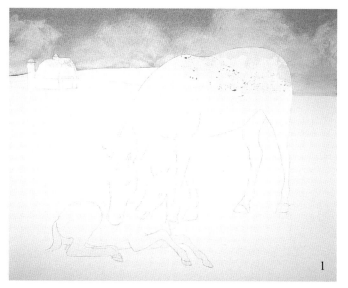

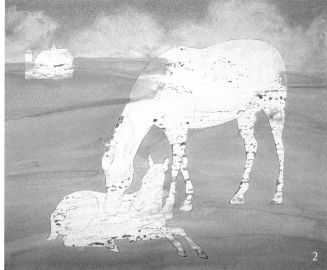

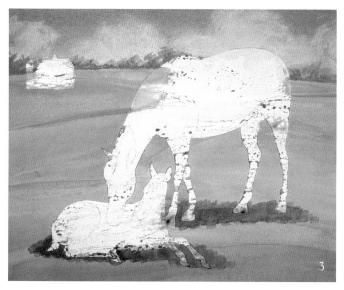

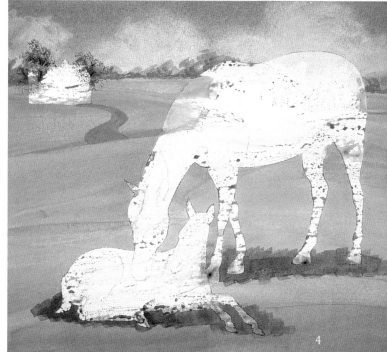

1. Sky. Wet the sky area with clean water, using the ¾-inch (19mm) flat. With the same brush, paint a wash of Ultramarine Blue + Light Blue Permanent (3:1) across the sky. While that is still wet, gently rub out the clouds, using a wad of facial tissue and stroking in a circular motion (see page 23).

Mix Titanium White + a touch of Naples Yellow Hue and use the mixture to add a little warmth to the clouds with the ¼-inch (6mm) flat.

2. Ground. Using the ½-inch (12mm) flat, mix several shades of green for the ground. Brush mix Light Blue Permanent + Hooker's Green Permanent Hue + Titanium White (2:1:1) for the most distant grass, and gradually add more Hooker's Green Permanent Hue as you move farther down the painting. Add Brilliant Yellow Green to the grass in the foreground. Let dry.

3. Distant Tree Line and Shadows. With loose, circular motions, add a distant line of trees with the ¼-inch (6mm) flat and the blue-green

mixture for the distant grass from step 2. Add a touch of Ultramarine Blue to the mix to shade the bottom of the tree line.

With the same brush, mix Sap Green Permanent and Ultramarine Blue (1:1) and paint the shadow under the horses with vertical strokes.

4. Trees and Path. Paint the path with Raw Umber + Titanium White (1:1). Next, use a small sea sponge to pat in the shapes of the trees behind the barn with Hooker's Green Permanent Hue. Add a few touches of Brilliant Yellow Green to the tree tops for a sun-dappled effect. Let dry.

Paint the trunk and branches with the no. 1 round and Raw Umber.

5. *Distant and Midground Grasses.* Mix several greens with various combinations of Hooker's Green Permanent Hue, Brilliant Yellow Green and Titanium White. Paint the distant and midground grasses with short, vertical strokes of the ⅛-inch (3mm) flat. Add patches of yellow grass with Naples Yellow Hue. Shade the path with Raw Umber, and add lights with a mixture of Titanium White + Raw Sienna (2:1). Add midtones with pure Raw Sienna. Let a little grass overlap the path.

6. *Bushes.* Using the ¼-inch (6mm) flat, lay in the bushes with a mixture of Sap Green Permanent + Ultramarine Blue (2:1) diluted with water until transparent. Glaze shadows under the bushes with a mixture of Hooker's Green Permanent Hue + Ultramarine Blue (2:1).

7. *Bushes.* Switch to the ⅛-inch (3mm) flat and brush mix several light greens with Titanium White + Hooker's Green Permanent Hue + Naples Yellow Hue in varying amounts. Paint the midtone leaves on the bushes with delicate back-and-forth strokes, then add lighter leaves over the top. Add glazes of Raw Sienna in some areas, if desired.

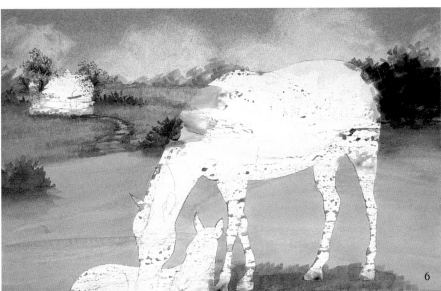

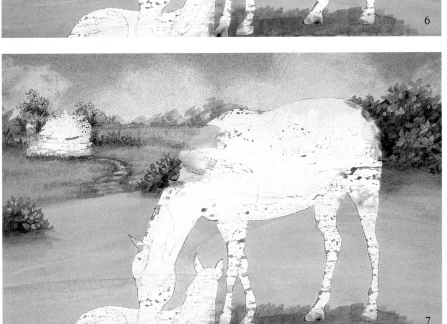

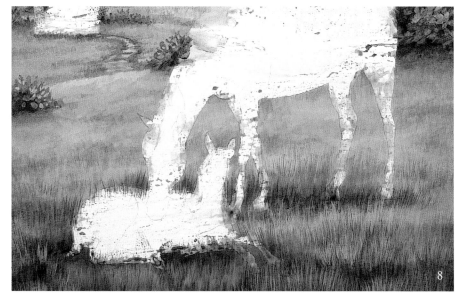

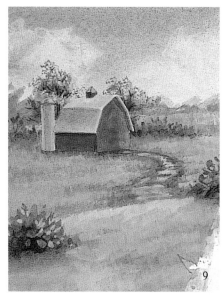

8. Foreground Grass. Use the ¼-inch (6mm) flat to add texture to the foreground grass with vertical strokes as you did in step 5, except your brushstrokes should be longer. Use various combinations of Hooker's Green, Titanium White, Brilliant Yellow Green Permanent Hue, Naples Yellow Hue and Raw Sienna. As you move down the painting, switch to the ¼-inch (6mm) grass comb/rake and paint the grass strokes.

9. Barn. Remove the mask from the barn. Using the ⅛-inch (3mm) flat, basecoat the barn with a mix of Red Oxide + a touch of Titanium White. For the roof and silo, use Titanium White + a generous touch of Raw Umber. Using the no. 1 round, shade the barn by adding a little Raw Umber to the Red Oxide mix. Shade the roof and silo by adding more Raw Umber to their basecoat mix.

10. Barn. Add the dark windows and details with pure Raw Umber. Add white details with Titanium White. Paint Titanium White tiles on the top of the roof and Raw Umber tiles on the bottom of the roof. Add a few Raw Umber horizontal lines to the silo (dilute the paint with water until it is thin and transparent). Add a few Red Oxide strips to the front of the barn.

11. Distant Cows. Tap in bushes next to the barn, using the ⅛-inch (3mm) flat, and the same colors as in steps 6 and 7. Transfer the cows. Using the no. 1 round, basecoat the cows with Burnt Umber + a touch of Titanium White. Render their heads with Titanium White + a slight touch of Burnt Umber. Detail with thin Burnt Umber and a mixture of Titanium White + a touch of Burnt Umber for highlights. Shade under the cows with Sap Green Permanent + Ultramarine Blue (1:1).

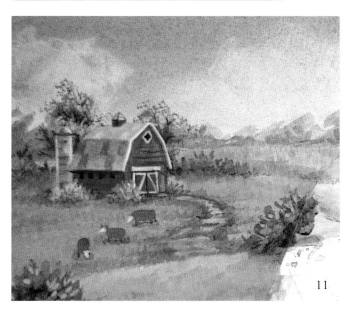

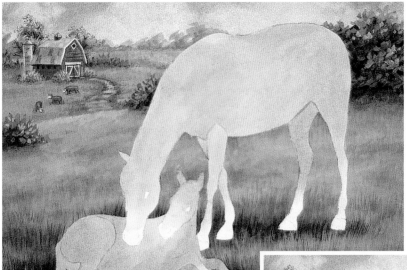

12. Horses. Remove the mask from the horses carefully, as it can stick tightly around the edges where the paint has overlapped it. Basecoat the horses with Raw Sienna and the ¼-inch (6mm) flat, leaving white paper for their noses and feet. (Blend the edges with clean water while the paint is still wet.)

13. Horses. Use the no. 4 round to shade the horses with Burnt Umber diluted with water until it is transparent. As you shade, blend with clean water before the paint dries. Let dry, then add the darkest shading with Raw Umber. For the eyes use Burnt Umber, and paint the hooves and nostrils with diluted Raw Umber.

14. Horses. Using the no. 1 round, brush mix Ultramarine Blue + Raw Umber (2:1) to make black, and paint the pupils of the eyes. Dilute the black with water to get a thin gray, then paint the muzzles and shade the hooves. Indicate the darks in the manes and tails with Raw Umber. Add the blaze to the bridge of each horse's nose with Titanium White.

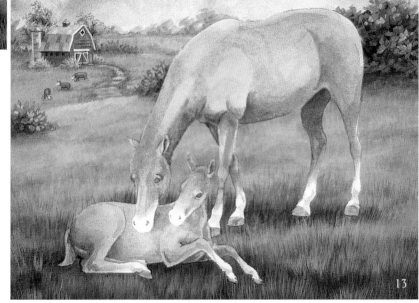

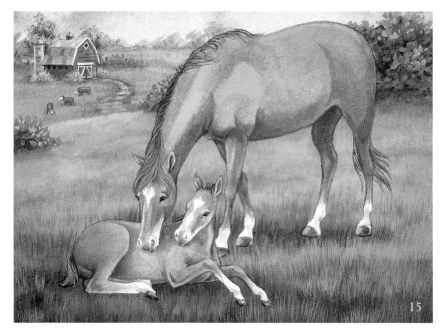

15. Horses. Highlight the horses with a mixture of Titanium White + a touch of Raw Sienna. Use the no. 4 round to highlight each body, and switch to the no. 1 round for the details and the manes and tails. Continue using the no. 1 round to go over the horses, touching up any details and shadows. Add a glaze of Burnt Sienna + a touch of Raw Sienna to the horses with the no. 4 round.

16. Flowers. Use the green mixes from steps 5 and 8 to bring grass up over the horses' hooves. Use the no. 1 round brush to paint the bluebonnets with a mixture of Ultramarine Blue + a touch of Titanium White. They can have somewhat of a Christmas tree shape. They should get smaller and less detailed as they recede into the background. Paint the stems with Hooker's Green Permanent Hue + Sap Green Permanent (1:1).

17. Flowers. Shade the bluebonnets with glazes of Ultramarine Blue, and detail them with Titanium White. Paint the leaves with the ⅛-inch (3mm) flat and Brilliant Yellow Green + Titanium White + Hooker's Green Permanent Hue (1:1: touch). Shade the leaves with Hooker's Green Permanent Hue and the no. 1 round brush.

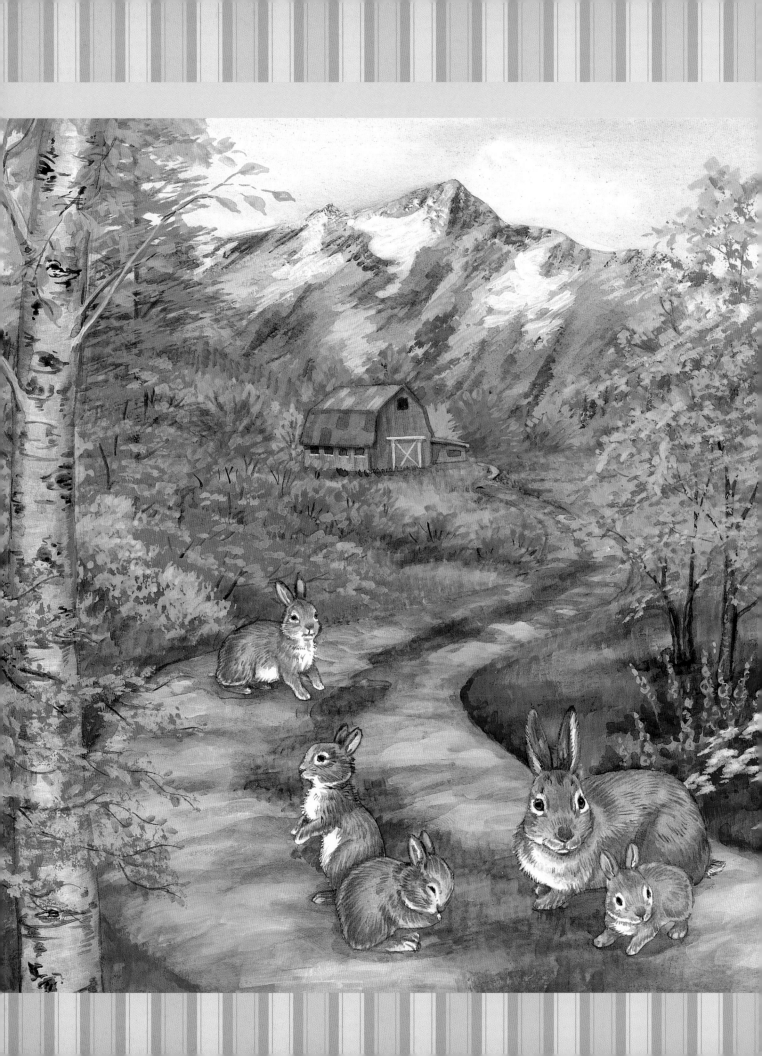

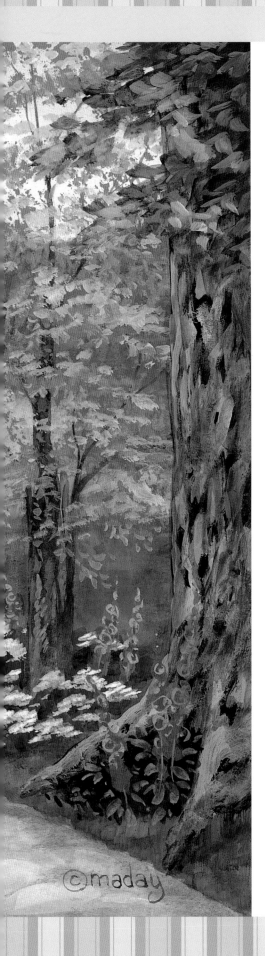

Hop To It

THIS YEAR several litters of baby bunnies were born in our yard. They were so sweet, and the children were thrilled to watch them grow. So far they have kept out of the garden, thank goodness!

MATERIALS LIST

Surface
9"× 12" (23cm × 30cm) Canson Montval acrylic paper 148lb (315gsm)

Brushes
½-inch (12mm) and ¾-inch (19mm) flats

⅛-inch (3mm) and ¼-inch (6mm) one-stroke flat washes

nos. 1, 2 and 4 rounds

Liquitex Soft Body Artist Acrylic Color
Brilliant Purple, Brilliant Yellow Green, Burnt Umber, Hooker's Green Permanent Hue, Light Blue Permanent, Medium Magenta, Naples Yellow Hue, Olive, Payne's Gray, Raw Sienna, Raw Umber, Red Oxide, Sap Green Permanent, Titanium White, Ultramarine Blue (Red Shade)

Additional Materials
Foamcore board

Sharp craft knife

Masking film or fluid

Wet palette

Water in a container

Drafting tape (*not* masking tape)

Sharp pencil or stylus

Graphite transfer paper

White transfer paper

Tracing paper

Facial tissue

Sea sponge

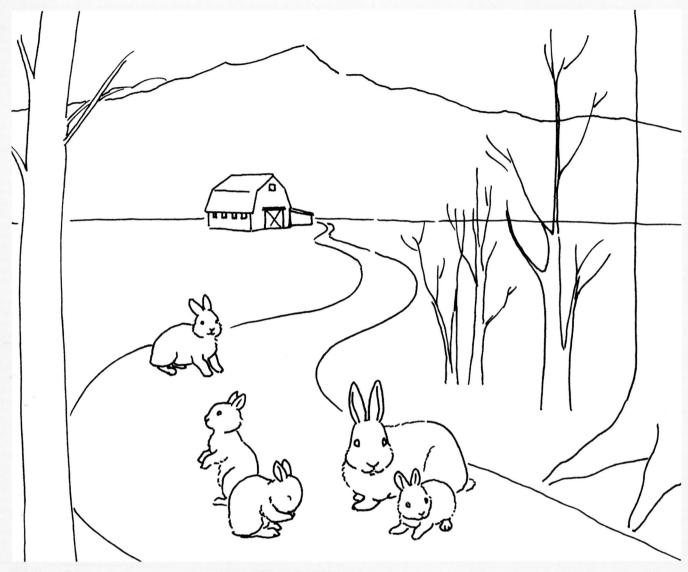

Pattern. This pattern may be hand-traced or photocopied for personal use only. Enlarge at 152% on a photocopier to bring it up to full size.

COLOR MIXTURES

Medium Magenta + Naples Yellow Hue (1:1)

Burnt Umber + Payne's Gray (2:1)

Hooker's Green Permanent Hue + Naples Yellow (1:1)

Hooker's Green Permanent Hue + Burnt Umber (1:1)

Sap Green Permanent + Ultramarine Blue (Red Shade) (1:1)

Sap Green Permanent + Light Blue Permanent + Titanium White (1:1: touch)

PREPARE FOR PAINTING

Use the drafting tape to tape the acrylic paper on all four sides to the foamcore support, leaving an 8" × 10" (20cm × 25cm) area for painting. Trace and transfer the bunnies, path, barn and mountain. You will transfer the trees and butterflies in steps 7 and 13. Cover the bunnies and barn with either masking fluid or masking film (see pages 14-15).

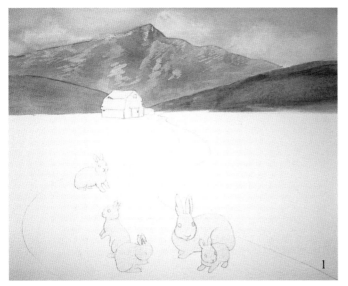

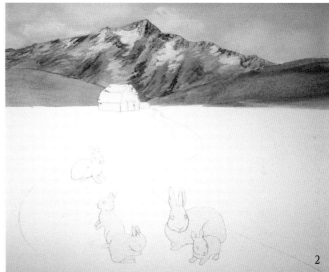

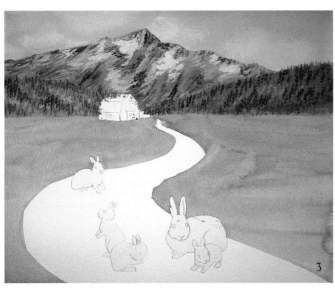

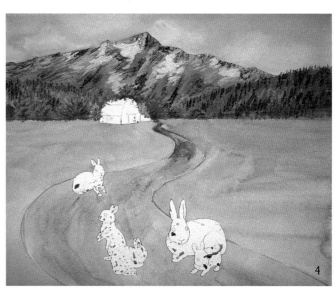

1. Sky and Mountain. Wet the sky area with clean water. Mix Light Blue Permanent + Ultramarine Blue (1:1), dilute with water, and paint a wash over the sky area with the ¾-inch (19mm) flat. While that is still wet, dab out some clouds with facial tissue (see page 23). Let dry, then paint a thin wash of Medium Magenta over the top.

Mix Burnt Umber + Payne's Gray (2:1), and paint a thin wash over the mountain with the ¾-inch (19mm) flat. Mix Titanium White + Raw Umber (2:1) and pat in texture on the mountain, using the chisel edge of the ¼-inch (6mm) flat. Paint a thin wash over the distant tree line with Sap Green Permanent + Ultramarine Blue (Red Shade) (1:1).

2. Mountain. Mix Burnt Umber + Payne's Gray (2:1) slightly thicker, so it is darker, and add the shadows to the mountain still using the chisel edge of the ¼-inch (6mm) flat. Glaze the tree line mixture from step 1 over the bottom of the mountains and Raw Sienna over the top portion. Then add Titanium White snow.

3. Evergreen Trees. With the chisel edge of the ¼-inch (6mm) flat, tap in evergreen trees with Sap Green Permanent + Light Blue Permanent + Titanium White (1:1: touch). For the darker trees use Sap Green Permanent + Ultramarine Blue (1:1) a little thicker than in the previous two steps. Paint the foreground grass with washes of Olive, using the ¾-inch (19mm) flat. Some of the Olive should overlap the distant trees.

4. Path and Distant Trees. Basecoat the path with a wash of Raw Umber. Mix various greens with assorted combinations of Hooker's Green Permanent Hue, Titanium White and Brilliant Yellow Green, and paint some trees and bushes around the barn with the ⅛-inch (3mm) flat. Paint some of the bushes with Naples Yellow Hue and Raw Sienna. For the darks use Hooker's Green Permanent Hue + Raw Umber (1:1).

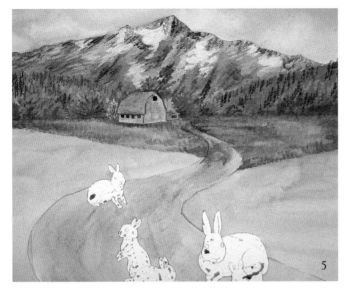

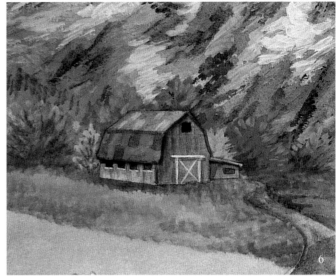

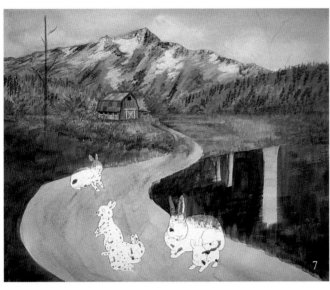

5. *Midground Grasses and Barn*. Use the greens from step 4 to paint the midground grasses with short, vertical strokes of the ¼-inch (6mm) flat, as shown. Remove the mask from the barn. Paint the barn with thin Red Oxide, and the roof with Raw Umber, using the no. 4 round. Use Payne's Gray for the windows.

6. *Barn*. Shade the barn with thin Burnt Umber. Shade the roof with a glaze of Payne's Gray. Paint a suggestion of vertical wood on the barn with Red Oxide. Paint the shingles on the roof Titanium White, Burnt Umber and Burnt Umber + Titanium White (1:1). Add details to the door and windows with Titanium White and the no. 1 round.

7. *Trees and Shrubs*. Transfer the tree trunks, except for the two largest. Paint the left trunk with Raw Umber and the edge of the ⅛-inch (3mm)

flat. Pat in the shrubs using Brilliant Purple on the ⅛-inch (3mm) flat. Make the lighter foliage from Brilliant Purple + Titanium White (1:1). Add little twigs with Burnt Umber + Payne's Gray (2:1) and the no. 1 round.

8. *Foreground Grass and Trees*. Paint the foreground grass with Hooker's Green Permanent Hue + Burnt Umber (1:1) and the ½-inch (12mm) flat. Use the Sap Green Permanent/Ultramarine Blue mixture from step 3 and paint foliage on the tree trunk with short horizontal strokes of the ¼-inch (6mm) flat. Add a little Titanium White to the mixture for lighter foliage, and use Brilliant Yellow Green for the lightest areas. Paint Olive down the center of the path with the ¼-inch (6mm) flat. Let the path fade to a thin wash of Payne's Gray as it recedes into the background.

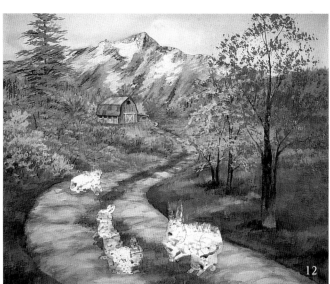

9. Trees and Foreground Grass. Mix several tints of Titanium White + touches of Raw Sienna and paint the path with curved horizontal strokes of the ¼-inch (6mm) flat. Paint the tree trunks on the right with Burnt Umber + a touch of Payne's Gray and the no. 4 round. Add the foreground grass as you did in the midground, but use larger vertical strokes.

10. Foliage. With the sea sponge, pat in some foliage with a mixture of Medium Magenta + Naples Yellow Hue (1:1). Don't rinse the sponge; pat in some overlapping Naples Yellow Hue foliage. Also add some Naples Yellow Hue foliage to the smaller tree trunks on the right.

11. Twigs. Use Raw Umber and the no. 1 round to paint twigs amongst the pink foliage. Add lighter blossoms by adding Titanium White to the pink mixture from step 10 and tapping it on with the ⅛-inch (3mm) flat. Use Raw Sienna to add darker leaves to the Naples Yellow Hue foliage. Mix Naples Yellow Hue + Titanium White (1:1) for the lighter leaves. Add more twigs to the trees, if desired. For the shadows under the trees use the Hooker's Green Permanent Hue/Burnt Umber mixture from step 8.

12. Foliage and Path. Use the sea sponge to pat Medium Magenta onto the largest tree trunk. Shade the path with glazes of Raw Umber and Ultramarine Blue using the ¼-inch (6mm) flat. Paint grass down the center of the path as you did in steps 5 and 8.

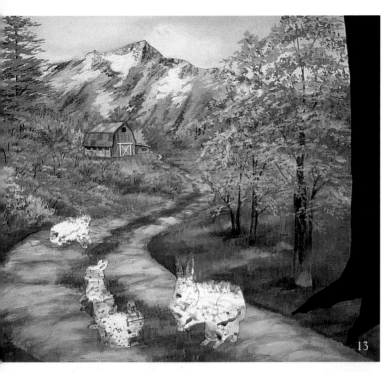

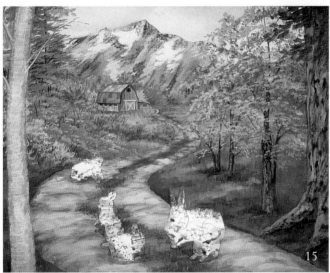

13. Tree. Mix Titanium White + Medium Magenta (2:1) and paint the lightest portions of the tree with the ⅛-inch (3mm) flat. Add a few green leaves with Brilliant Yellow Green + a touch of Hooker's Green Permanent Hue and the no. 1 round. Transfer the largest tree trunks and basecoat the one on the right with the Burnt Umber + Payne's Gray mixture from step 7.

14. Trees. Paint the right-hand trunk with loose, random strokes of Titanium White + Raw Umber (2:1) and the ¼-inch (6mm) flat. When that's dry, glaze Raw Umber shading over the top. Add a shadow to the grass under the trunk with the Hooker's Green Permanent Hue + Burnt Umber mixture. Basecoat the left-hand trunk with Raw Umber + a touch of Titanium White.

15. Foliage. Paint leaves on the right-hand tree with Hooker's Green Permanent Hue + Raw Umber (1:1) and back-and-forth strokes of the ¼-inch (6mm) flat. Paint leaves behind the left-hand tree with Hooker's Green Permanent Hue + Naples Yellow Hue (1:1). Paint the trunk with slightly curved horizontal strokes of Titanium White. Add details to the smaller tree trunks with the Titanium White + Raw Umber mixture from step 14 and the chisel edge of the ⅛-inch (3mm) flat.

16. Foliage and Flowers. Use the various grass mixtures to paint leaves in the upper-right corner with the ⅛-inch (3mm) flat. Glaze more Hooker's Green Permanent Hue + Burnt Umber under the trees. Stipple Titanium White + a touch of Ultramarine Blue with the 1/8-inch (3mm) flat. Stipple pure Titanium White over the top. Pat in flower spikes with the chisel edge of the brush and Brilliant Purple.

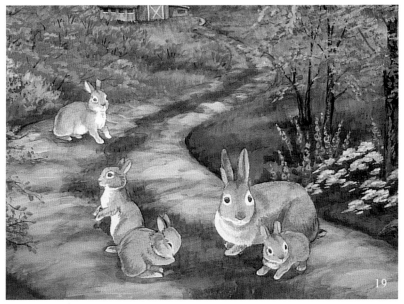

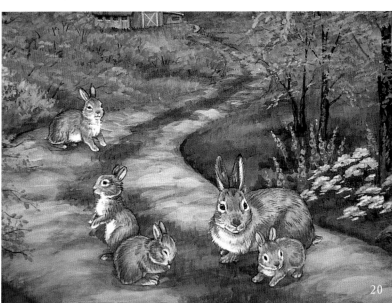

17. *Foliage and Flowers*. Shade the tree on the left with glazes of Payne's Gray. Add a few touches of Naples Yellow Hue, and add details with the Burnt Umber + Payne's Gray mixture from step 7 and the no. 1 round. With the no. 1 round, add highlights to the purple spikes with Titanium White + Brilliant Purple (2:1). For the darks use touches of Ultramarine Blue. Use Hooker's Green Permanent Hue + Titanium White (1:1) for the leaves and stems.

18. *Foliage*. Add leaves to the upper left with the no. 2 round. For some use Naples Yellow Hue, and for others use Brilliant Yellow Green + a touch of Hooker's Green Permanent Hue. Paint extra twigs with the no. 1 round and the Burnt Umber + Payne's Gray (2:1) mixture. Paint the pink blossoms with Medium Magenta as you did for the tree on the right.

19. *Bunnies*. Remove the masking fluid or film from the bunnies. Basecoat the bunnies with very thin Raw Umber and the no. 2 round. Leave plain paper for the white fur. Paint the eyes with Burnt Umber and a no. 1 round. Glaze Red Oxide into the ears. Glaze a little shading with very thin touches of the Burnt Umber + Payne's Gray mixture, using the no. 2 round.

20. *Bunnies*. Add details with delicate little strokes of the no. 1 round. The eyes have Payne's Gray pupils, the fur has little Raw Umber hairs, and a few white hairs are added with Titanium White.

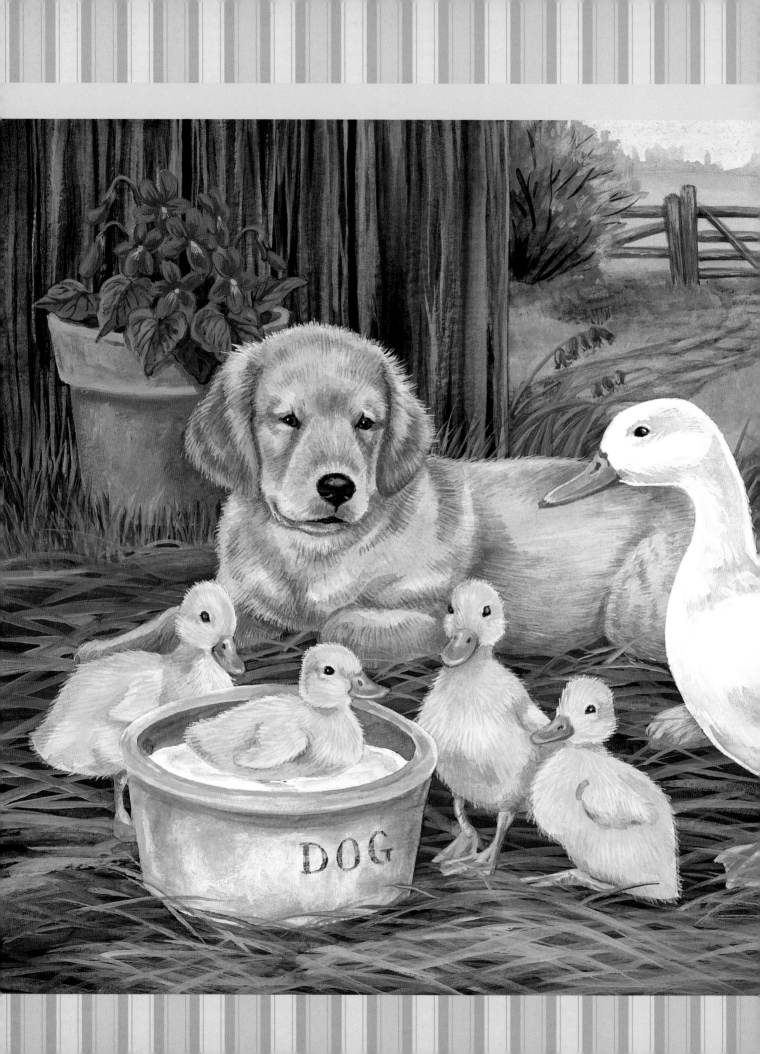

Just Ducky

MY CHILDREN will look for any excuse to go swimming, and it looks as if this little duckling feels the same way! This painting shows how masking film can help you paint a design with many overlapping elements.

MATERIALS LIST

Surface
9" × 12" (23cm × 30cm) Canson Montval acrylic paper 148lb (315gsm)

Brushes
¾-inch (19mm) flat

⅛-inch (3mm) and ¼-inch (6mm) one-stroke flat washes

nos. 1 and 4 rounds

⅛-inch (3mm) and ¼-inch (6mm) grass comb/rake (homemade or purchased, see page 12)

Liquitex Soft Body Artist Acrylic Colors
Brilliant Yellow Green, Burnt Umber, Cadmium Yellow Medium Hue, Hooker's Green Permanent Hue, Naples Yellow Hue, Olive, Payne's Gray, Prism Violet, Raw Sienna, Raw Umber, Red Oxide, Sap Green Permanent, Titanium White, Ultramarine Blue (Red Shade)

Additional Materials
Foamcore board

Sharp craft knife

Masking film

Wet palette

Water in a container

Drafting tape (*not* masking tape)

Sharp pencil or stylus

Graphite transfer paper

White transfer paper

Tracing paper

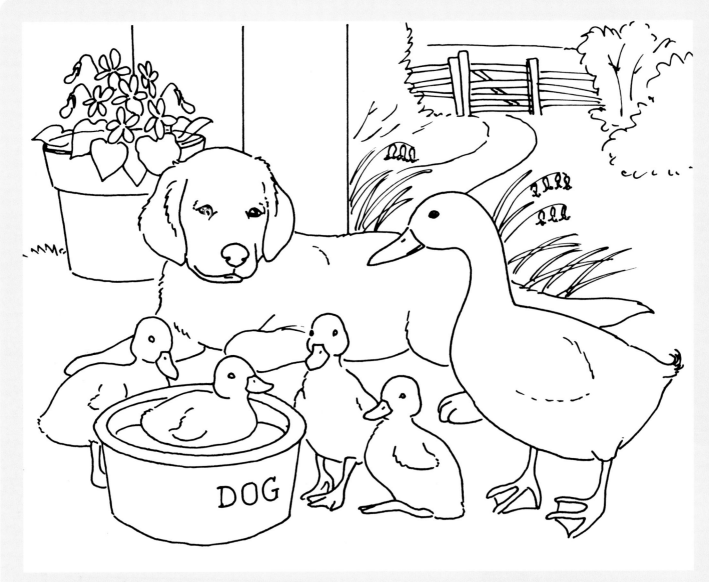

Pattern. This pattern may be hand-traced or photocopied for personal use only. Enlarge at 152% on a photocopier to bring it up to full size.

COLOR MIXTURES

 Red Oxide + Raw Sienna (1:1)

 Raw Sienna + Red Oxide + Titanium White (2:1:1)

 Cadmium Yellow Medium Hue + Red Oxide (1:1)

 Naples Yellow Hue + Cadmium Yellow Medium Hue (1:1)

 Naples Yellow Hue + Hooker's Green Permanent Hue (1:1)

 Hooker's Green Permanent Hue + Naples Yellow (2:1)

 Ultramarine Blue + Hooker's Green Permanent Hue (1:1)

 Ultramarine Blue + Prism Violet + Titanium White (2:1:1)

 Prism Violet + Titanium White + Ultramarine Blue (1:1: touch)

 Prism Violet + Ultramarine Blue (1:1)

 Payne's Gray + Raw Umber (2:1)

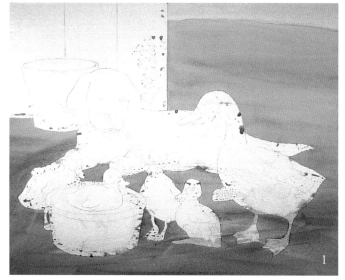

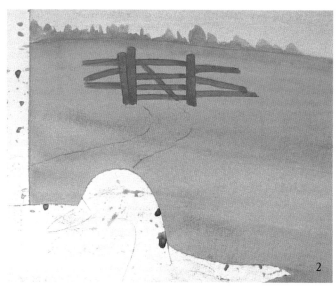

PREPARE FOR PAINTING

Using drafting tape, tape the acrylic paper on all four sides to the foam-core support, leaving an 8" × 10" (20cm × 25cm) area for painting. Trace and transfer the design, except the gate, path, bushes and flowers. For this design, it is better to use masking film rather than masking fluid, so you can remove it a little at a time. To begin, mask the wall, the flowerpot, the dog, the ducks and the dog's water dish. Only cut as much film as necessary; do not cut the separations between the objects until you need to remove the film as the paint can sometimes seep into the cuts.

1. Sky and Ground. Dilute Ultramarine Blue until it is very thin and transparent, and paint the sky with the ¾-inch (19mm) flat. Next, paint the midground with a thin wash of Olive and the foreground with Raw Umber. The washes do not need to be flat, as you will paint over them.

2. Distant Trees and Fence. Transfer the gate and path. Dilute Brilliant Yellow Green with water, and paint a wash over the background grass with the no. 4 round. While that is still wet, paint the line of distant trees with a very thin mixture of Ultramarine Blue + Hooker's Green Permanent Hue (1:1), still using the no. 4 round. Let that blend into the grass. Basecoat the fence with Burnt Umber + Titanium White (1:1).

3. Bushes and Path. Mix Naples Yellow Hue + Hooker's Green Permanent Hue (1:1) and paint the bushes next to the gate with the ¼-inch (6mm) flat. For the darker bush mix Hooker's Green Permanent Hue + Ultramarine Blue thicker so it is darker. Use a wash of Raw Sienna for the path.

4. Foliage and Gate. With the ⅛-inch (3mm) flat, paint the darker foliage with Ultramarine Blue + Hooker's Green Permanent Hue (2:1). For the warm foliage use Raw Sienna. Make the lightest leaves from Brilliant Yellow Green + Titanium White (1:1). Paint the branches with Raw Umber and the no. 1 round. Shade the gate with Burnt Umber.

5

6

7

8

5. *Midground Grass and Gate*. With the ¼-inch (6mm) flat, paint the midground grass with short, vertical strokes, using Olive, Hooker's Green Permanent Hue, Brilliant Yellow Green and Naples Yellow. Your strokes should get bigger as you move down the page. Highlight the gate with Titanium White + Raw Sienna (2:1).

6. *Gate and Path*. With the ⅛-inch (3mm) flat, glaze Olive over the gate. Shade the path with Raw Umber and highlight it with the Titanium White + Raw Sienna mixture from step 5. Transfer the bluebells behind the dog.

7. *Flowers*. Paint some back-and-forth strokes of Sap Green Permanent where the bluebells will go, using the ¼-inch (6mm) flat. Use the no. 4 round to paint the leaves and stems with Hooker's Green Permanent Hue + Titanium White (1:1). Add more Hooker's Green Permanent Hue to the mixture and paint more leaves. Mix Ultramarine Blue + Prism Violet + Titanium White (2:1:1) and paint the bluebells with the no. 1 round.

8. *Flowers and Barn Wall*. With the no. 1 round, paint details on the leaves with Hooker's Green Permanent Hue + a touch of Ultramarine Blue. Add more Ultramarine Blue and Prism Violet to the flower mix for shading, then add more Titanium White for highlighting. Glaze a couple of blossoms with thin Prism Violet. Uncover the wall and basecoat it with Raw Umber, using the ¾-inch (19mm) flat.

9. Wall. Glaze Payne's Gray over the wall. With the ¼-inch (6mm) grass comb/rake, paint wood grain with a mixture of Payne's Gray + Raw Umber (2:1). Vary the pressure on the brush so the lines vary in width. Darken the grass under the wall with Hooker's Green Permanent Hue + Ultramarine Blue (2:1).

10. Wall. Add Titanium White to the wood grain mixture from step 9 and paint lighter streaks with the no. 4 round. Glaze over the top with Payne's Gray in some areas and Raw Umber in others.

11. Wall. Retransfer the spaces between the boards with the white transfer paper. With the no. 4 round, paint the spaces with the wood grain mixture from step 9, but use the paint a bit thicker so it is darker. Add a few more highlights with the highlight mixture from step 10. Begin painting the grass with the ¼-inch (6mm) grass comb/rake brush and Hooker's Green Permanent Hue + Ultramarine Blue (2:1).

12. Flowerpot. Mix several greens with varying amounts of Hooker's Green + Brilliant Yellow Green. Use the no. 1 round to paint individual blades of grass by the wall. Glaze more Raw Umber over the ground. Remove the mask from the flowerpot and basecoat it with Red Oxide + Raw Sienna (1:1) and the no. 4 round.

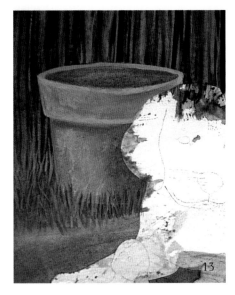 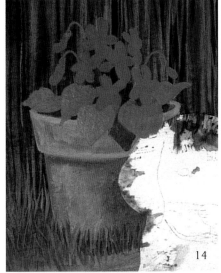 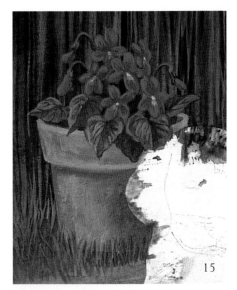

13. *Flowerpot.* Paint texture on the flowerpot by dry brushing with Naples Yellow Hue and Raw Sienna and the ⅛-inch (3mm) flat. Shade with glazes of Raw Umber. Glaze patches of Olive + Titanium White (2:1). Bring grass up over the bottom of the pot using green mixes from step 5.

14. *Violets.* Transfer the violets with the white transfer paper. Basecoat the leaves and stems with Sap Green Permanent + Titanium White (2:1), using the no. 4 round. Paint the darker leaves with Hooker's Green + Ultramarine Blue (2:1). For the violets, use Prism Violet + Titanium White + Ultramarine Blue (2:1: touch).

15. *Violets.* Dot Naples Yellow Hue in the centers of the flowers. Shade the leaves with a glaze of Hooker's Green Permanent + Ultramarine Blue (1:1). Shade the violets with Prism Violet + Ultramarine Blue (1:1). Highlight by adding a little Titanium White to the basecoat mixture from step 14. Add a few strokes of Titanium White below the yellow dot. Use the leaf-shading mixture less diluted to add dark details to the leaves. Highlight with Titanium White + Hooker's Green Permanent Hue (2:1).

16. *Straw.* Paint the straw with random strokes of Naples Yellow Hue, Raw Sienna and Hooker's Green Permanent Hue + Naples Yellow Hue (2:1), using the no. 4 round. When that's dry, glaze shadows with Raw Umber. For the lightest straw use Naples Yellow Hue + Titanium White (1:1). Uncover the puppy.

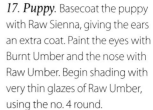

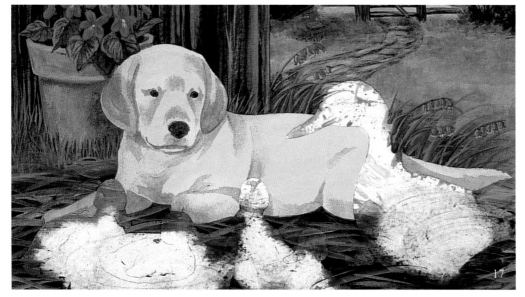

17. Puppy. Basecoat the puppy with Raw Sienna, giving the ears an extra coat. Paint the eyes with Burnt Umber and the nose with Raw Umber. Begin shading with very thin glazes of Raw Umber, using the no. 4 round.

18. Puppy. Detail the nose, eyes and mouth with Payne's Gray + a touch of Raw Umber and the no. 1 round. Highlight the nose with Titanium White + Payne's Gray (2:1). Give the eyes Titanium White highlights. Dilute Burnt Umber until very thin, and paint the darker hairs with the ⅛-inch (3mm) grass comb/rake.

19. Puppy. Paint the light fur with Titanium White + a touch of Raw Sienna. The paint should have a creamy texture. Be sure to follow the direction of the hair growth. Imagine stroking the animal; your brush should follow the same path as your hand would.

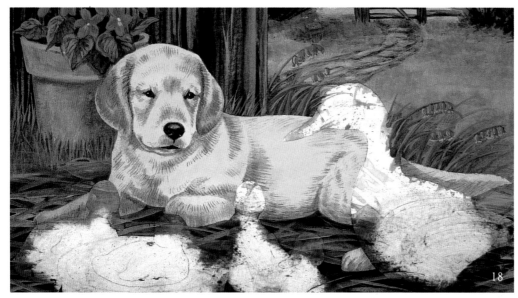

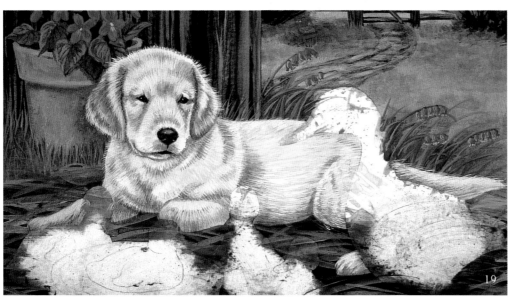

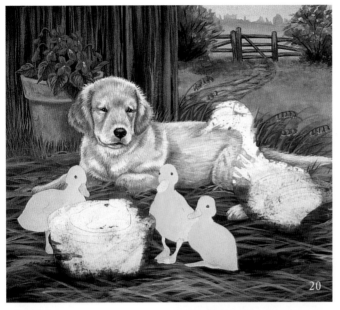

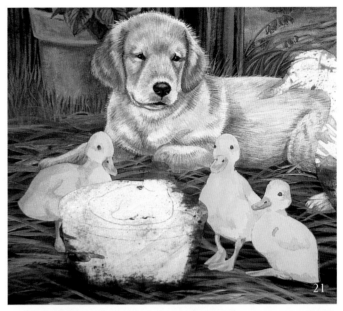

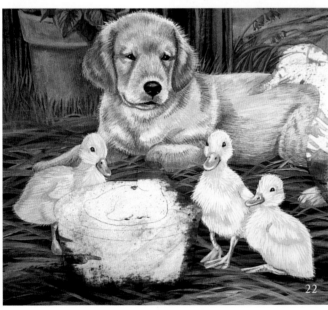

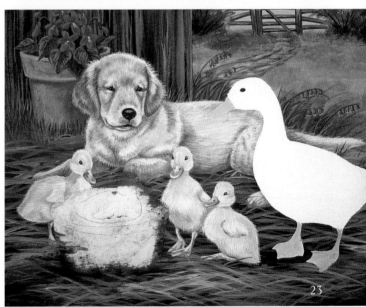

20. Puppy and Ducklings. Glaze Raw Sienna over the dog with the no. 4 round, leaving some of the lightest hairs as highlights. Paint some straw and grass to overlap the tummy, legs and tail. Uncover the ducklings, except the one in the dish. Basecoat them with thin Naples Yellow Hue. For the beaks and legs use Raw Sienna + Red Oxide + Titanium White (2:1:1), and for the eyes use Burnt Umber.

21. Ducklings. Shade the legs and beaks with Raw Sienna + Red Oxide (2:1), using the no. 1 round. Render the nostrils with Raw Umber. Glaze shading on the ducklings with Raw Sienna and the no. 4 round.

22. Ducklings. Detail the legs and beaks with Raw Umber and the no. 1 round, and highlight with Titanium White. Detail the eyes with

Payne's Gray, and highlight them with Titanium White. Mix Titanium White + a touch of Naples Yellow Hue and paint the fluffy feathers with the ⅛-inch (3mm) grass comb/rake.

23. Ducklings and Duck. Glaze Naples Yellow Hue + Cadmium Yellow Medium Hue (1:1) over the feathers, leaving the lightest feathers white. Glaze some very thin Burnt Umber in the shaded areas. Bring some straw up over the feet using color mixes from step 16. Remove the mask from the duck. Paint the beak and legs as you did for the ducklings. Use Burnt Umber for the eye.

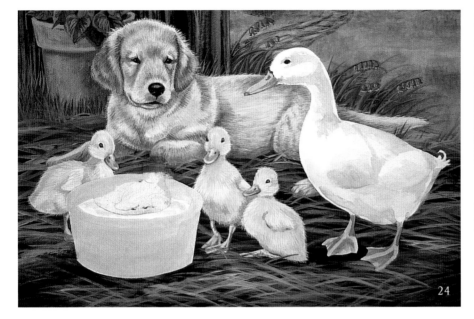

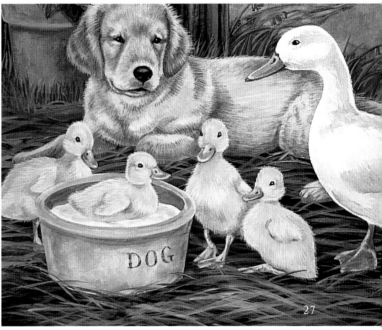

24. Duck and Dish. Shade the duck with diluted Raw Umber and the no. 4 round. Shade the beak and legs with Raw Umber as well. Glaze Naples Yellow Hue on the shaded areas of the duck. Uncover the dog's dish. Basecoat it with Titanium White + a generous touch of Raw Umber. Paint the water with glazes of Ultramarine Blue and Naples Yellow Hue.

25. Dish. Shade the dish with glazes of Raw Umber. With the ⅛-inch (3mm) flat, drybrush Titanium White, Naples Yellow Hue, and Olive + Titanium White (1:1) in patches on the dish. Blend the wet paint with your finger, if desired. Using color mixes from step 16, paint some straw overlapping the bottom of the dish.

26. Duck. Glaze the mother duck's beak with Cadmium Yellow Medium Hue + Red Oxide (1:1). Highlight with Titanium White. Detail the eye with Payne's Gray, and highlight with Titanium White, using the no. 1 round. With the same brush, paint white feathers overlapping the shading on the duck. Add some very thin Raw Umber details if necessary. Paint some straw overlapping the feet.

27. Dish and Duckling. If desired, transfer the word *dog* onto the dish, and paint it with Raw Umber and the no. 1 round. Drybrush a little Titanium White over the letters to age them. Remove the mask from the duckling in the dish and paint it as you did the other ducklings.

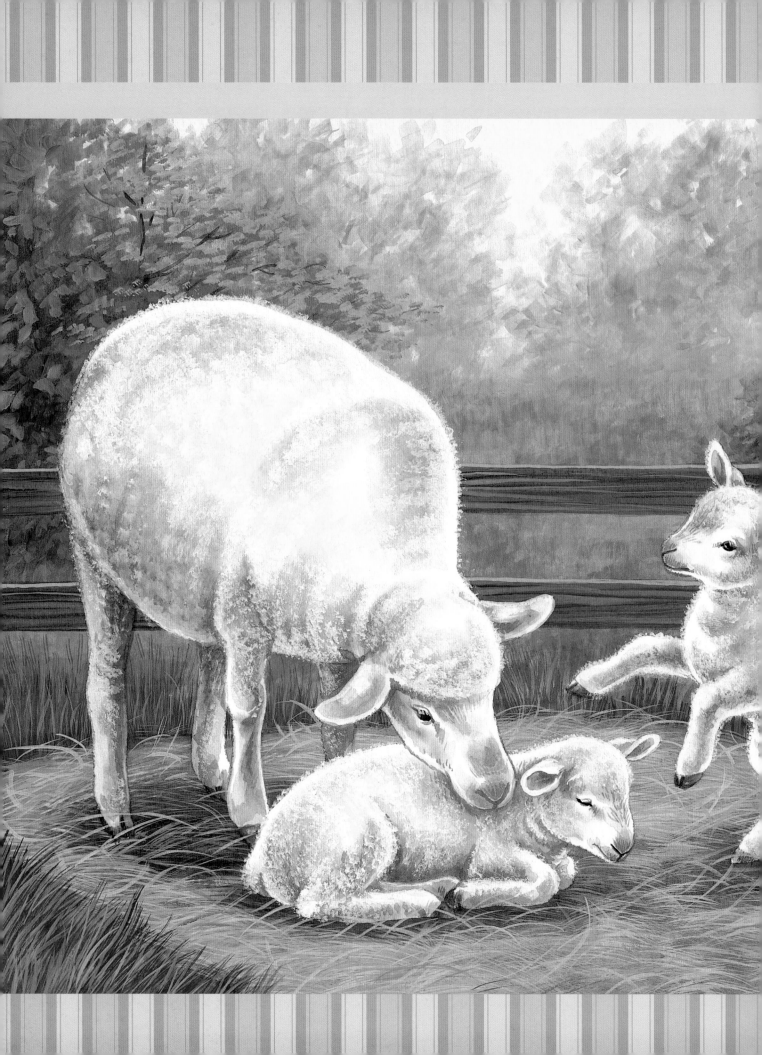

Rise and Shine

I WONDER if a mama sheep has as much trouble waking her little lambs in the morning as I do!

MATERIALS LIST

Surface
9" × 12" (23cm × 30cm) Canson Montval acrylic paper 148lb (315gsm)

Brushes
¾-inch (19mm) flat

⅛-inch (3mm) and ¼-inch (6mm) one-stroke flat washes

nos. 1, 2 and 4 rounds

¼-inch (6mm) grass comb/rake (home-made or purchased, see page 12)

Old bright bristle or scruffy brush

Liquitex Soft Body Artist Acrylic Colors
Brilliant Purple, Burnt Sienna, Cadmium Red Medium Hue, Hooker's Green Permanent Hue, Light Blue Permanent, Medium Magenta, Naples Yellow Hue, Olive, Payne's Gray, Raw Sienna, Raw Umber, Titanium White, Ultramarine Blue (Red Shade)

Additional Materials
Foamcore board

Sharp craft knife

Masking film or fluid

Wet palette

Water in a container

Drafting tape (*not* masking tape)

Sharp pencil or stylus

Graphite transfer paper

Tracing paper

Raw Umber pastel pencil

Raw Sienna pastel pencil

Cotton swabs

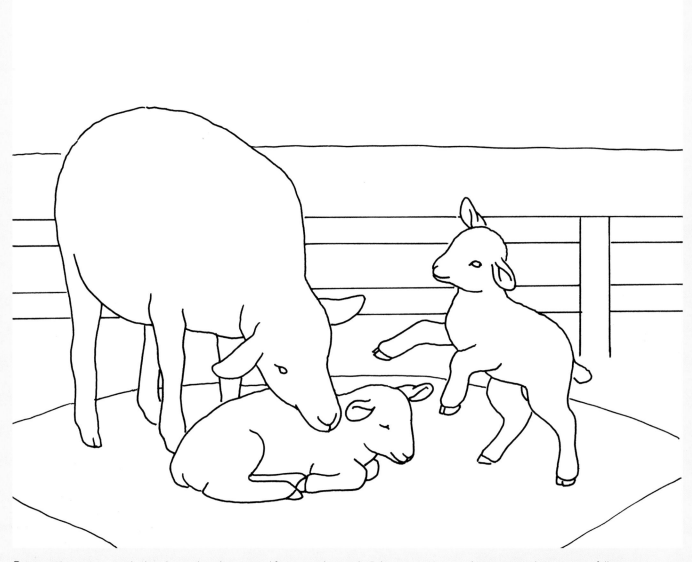

Pattern. This pattern may be hand-traced or photocopied for personal use only. Enlarge at 152% on a photocopier to bring it up to full size.

COLOR MIXTURES

Medium Magenta + Naples Yellow Hue + Titanium White (2:1: touch)

Cadmium Red Medium Hue + Naples Yellow Hue + Titanium White (1:1:1)

Raw Umber + Payne's Gray (2:1)

Titanium White + Raw Umber + Naples Yellow Hue (2:1: touch)

Hooker's Green Permanent Hue + Raw Umber (1:1)

Olive + Light Blue Permanent + Titanium White (1:1:1)

Light Blue Permanent + Brilliant Purple + Olive (1:1: touch)

PREPARE FOR PAINTING

Using drafting tape, tape the acrylic paper on all four sides to the foamcore support, leaving an 8" × 10" (20cm × 25cm) area for painting. Trace and transfer the design. Cover all three sheep with masking film or fluid.

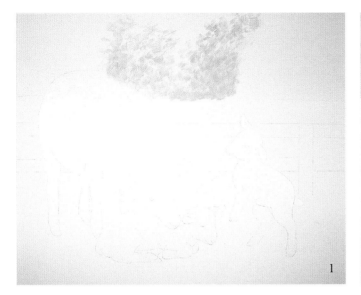

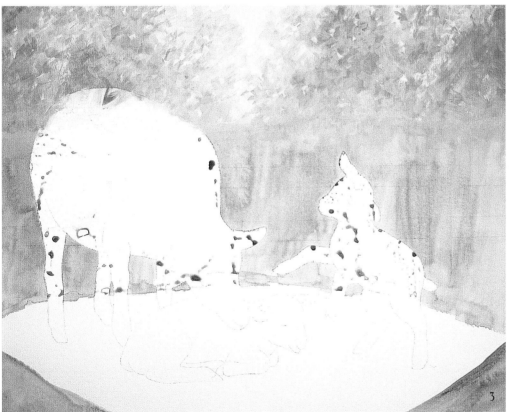

1. Sky and Foliage. Wet the sky area with clean water and the ¾-inch (19mm) flat. Paint the sky with a mix of Titanium White + a touch of Naples Yellow Hue. Mix Olive + Light Blue Permanent + Titanium White (1:1:1) and paint loose foliage in the background with the ¼-inch (6mm) flat. Make sure some sky shows through.

2. Foliage. Mix Light Blue Permanent + Brilliant Purple + Olive (1:1: slight touch) and paint more foliage over the sky color with the ¼-inch (6mm) flat. The lighter green foliage should still show around space in the center. Slip-slap a little Titanium White around the edges.

3. Grass. Mix Titanium White + Medium Magenta (3:1) and paint with random slip-slap strokes over the background foliage. Make sure the sky still shows through in places. Switch to the ¾-inch (19mm) flat and basecoat the grass with Olive that has been diluted with water. Mix Titanium White + Olive and soften the edge where the bushes meet the grass, using the ¼-inch (6mm) flat and short, vertical strokes.

4. Ground. Paint the ground under the sheep with a wash of Raw Umber and the ¾-inch (19mm) flat. Use Hooker's Green Permanent Hue, Olive, Naples Yellow Hue and Titanium White to mix various greens. Paint the grasses with short vertical strokes of the ¼-inch (6mm) flat.

5. Bushes. Paint the bushes with Hooker's Green Permanent Hue + Raw Umber (1:1) and the ¼-inch (6mm) flat. Add shadows under the sheep with Raw Umber + Payne's Gray (2:1). Add very thin glazes of Hooker's Green Permanent Hue to the background.

6. Bushes and Fence. Add twigs in the bushes with Raw Umber and the no. 1 round. Paint light leaves with the ⅛-inch (3mm) flat and Titanium White + Hooker's Green Permanent Hue (2:1). Glaze Hooker's Green Permanent Hue over some of the light leaves. Paint the fence with Raw Umber + Titanium White (2:1) and the ¼-inch (6mm) flat.

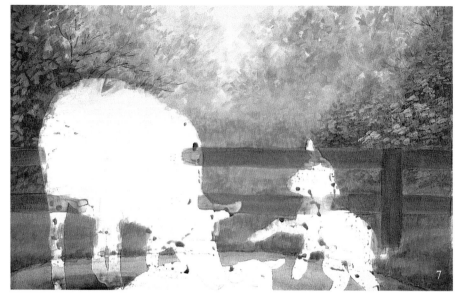

7. Fence and Bushes. Glaze Raw Umber over the fence. Mix Medium Magenta + Naples Yellow Hue + Titanium White (2:1: touch), and paint blossoms on the front left-hand bush with the ⅛-inch (3mm) flat. Add more Titanium White for the lighter touches. Paint Naples Yellow Hue blooms on the rear left-hand bush, and add a little Titanium White for the lighter blooms. Add a few Naples Yellow Hue touches to the Medium Magenta blooms as well.

8. Bushes and Fence. Mix Cadmium Red Medium Hue + Naples Yellow Hue + Titanium White (1:1:1) and paint blossoms on the left-hand bush. Add more Titanium White for the lighter blooms. Highlight the tops of the fence boards with Titanium White + Raw Umber + Naples Yellow Hue (2:1: touch) and the no. 0 round. Begin adding wood grain with Raw Umber.

9. Fence and Grass. Add more wood grain with the fence highlighting mixture from step 8 and the no. 1 round. Glaze over the top with Raw Umber and the ¼-inch (6mm) flat when dry. Use Payne's Gray for the nails. Use the ¼-inch (6mm) grass comb/rake to paint grass strokes under and around the fence with the green mixtures from step 3.

10. Straw. Paint the straw with random horizontal strokes of the ¼-inch (6mm) grass comb/rake, using Naples Yellow Hue, Naples Yellow Hue + Titanium White (1:1), and Hooker's Green Permanent Hue + Naples Yellow Hue + Titanium White (1:1: touch). Glaze more shading under the sheep with the shadow mixture from step 5.

11. Straw and Sheep. Add individual straws with the no. 1 round. Next, use color mixtures from step 3 to paint the foreground grass with the ¼-inch (6mm) grass comb/rake, then add individual grass blades with the no. 1 round. Remove the mask from the sheep.

12. Sheep. Paint Naples Yellow Hue over the sheep with the no. 4 round, leaving plain paper for the white areas. Mix Ultramarine Blue + Burnt Sienna (1:1), dilute with water until very thin and transparent, and paint the shading on the sheep. Switch to the no. 1 round and paint the eyes with Raw Umber.

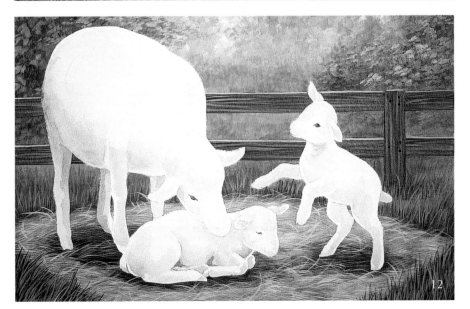

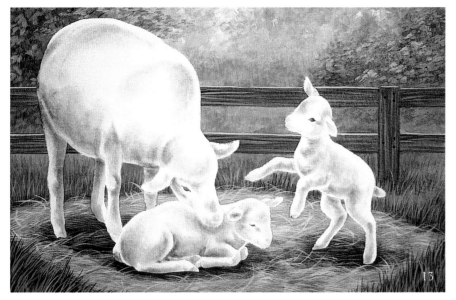

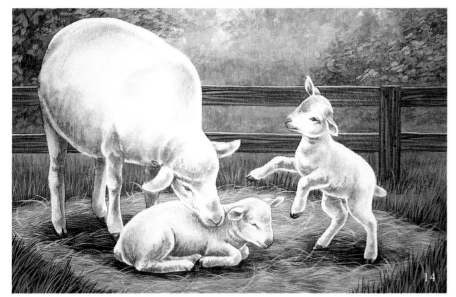

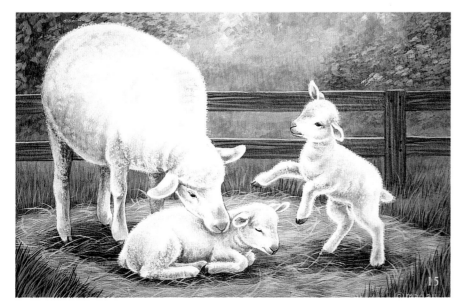

13. Sheep. Rub a cotton swab across a Raw Umber (or other warm brown) pastel pencil, picking up some pigment on the tip. Add more shading to the sheep by rubbing the pigment onto the paper (See page 19). This gives a very soft effect. Next, rub a swab over a Raw Sienna pastel pencil and add more pigment to the sheep.

14. Sheep. Dilute the blossom mixture from step 8, and paint pink washes onto the ears and noses, using the no. 2 round. Add darker details with Raw Umber. Use the Raw Umber + Payne's Gray mixture from step 5 for the feet. Switch to the no. 1 round for the finer details.

15. Sheep. Holding your old bright bristle brush (or scruffy brush) straight up and down, stipple Titanium White fleece onto the sheep. Notice how the fleece grows in "rows." Blot the white paint on the brush before stippling so it is not too gloppy. Use the no. 1 round to add white details to the face and to detail the eyes with Payne's Gray. Finally, using color mixtures from step 10, paint a few pieces of straw overlapping the feet.

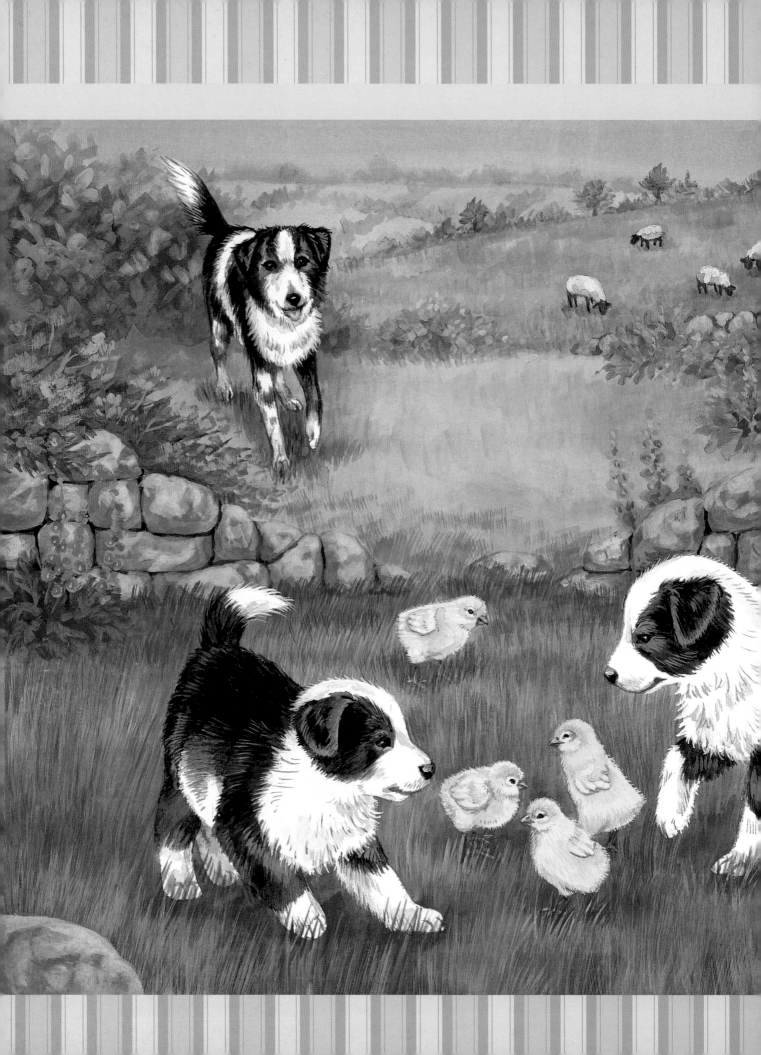

First Day on the Job

THESE BORDER COLLIE PUPPIES
are too small to work with the sheep,
so they'll have to practice on these little
chicks instead!

MATERIALS LIST

Surface
9" × 12" (23cm × 30cm) Canson Montval
acrylic paper 148lb (315gsm)

Brushes
¾-inch (19mm) flat

⅛-inch (3mm) and ¼-inch (6mm) one-
stroke flat washes

nos. 1, 2 and 4 rounds

¼-inch (6mm) grass comb/rake (home-
made or purchased, see page 12)

Liquitex Soft Body Artist Acrylic Colors
Brilliant Yellow Green, Burnt Umber,
Cadmium Red Medium Hue, Cadmium
Yellow Medium Hue, Hooker's Green
Permanent Hue, Ivory Black, Light Blue
Permanent, Naples Yellow Hue, Payne's
Gray, Raspberry, Raw Sienna, Raw Umber,
Sap Green Permanent, Titanium White,
Ultramarine Blue (Red Shade)

Additional Materials
Foamcore board

Sharp craft knife

Masking film or fluid

Wet palette

Water in a container

Drafting tape (not masking tape)

Sharp pencil or stylus

Graphite transfer paper

White transfer paper

Tracing paper

Pattern. This pattern may be hand-traced or photocopied for personal use only. Enlarge at 152% on a photocopier to bring it up to full size.

COLOR MIXTURES

Raw Umber + Titanium White + Naples Yellow Hue (1:1:1)

Titanium White + Hooker's Green Permanent Hue + Ultramarine Blue (3:2:1)

Ultramarine Blue + Hooker's Green Permanent Hue (2:1)

Ultramarine Blue + Light Blue Permanent (2:1)

Ultramarine Blue + Raspberry (1:1)

Raw Umber + Payne's Gray (2:1)

Payne's Gray + Titanium White + Raw Umber (1:1: touch)

PREPARE FOR PAINTING

Use drafting tape to tape the acrylic paper on all four sides to the foamcore support, leaving an 8" × 10" (20cm × 25cm) area for painting. Trace and transfer the design, except the bushes and distant sheep. Use masking film or masking fluid to protect the dogs and bodies of the chicks as instructed on pages 14-15. You can leave the chicks' legs uncovered, as they are so small and delicate.

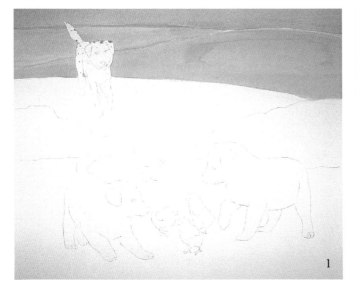

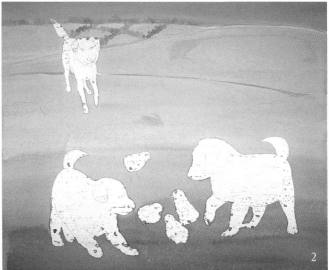

*1. **Sky and Distant Field**.* Wet the sky with clean water, using the ¾-inch (19mm) flat. Paint a wash of Ultramarine Blue + Light Blue Permanent (2:1) across the sky, using the same brush. Add a touch of Brilliant Yellow Green to the sky mixture and paint the most distant field. Add more Brilliant Yellow Green for the middle field.

*2. **Fields**.* Gradually add Hooker's Green Permanent Hue to the field mixture as you move down the painting. Don't worry about getting a flat wash, as you will paint over it. Mix Titanium White + Hooker's Green Permanent Hue + Ultramarine Blue (3:2:1) and paint the distant hedgerows with the ⅛-inch (3mm) flat. Glaze a little of the sky mixture from step 1 over the top to help them recede.

*3. **Distant Field**.* Add more Hooker's Green Permanent Hue to the hedgerow mixture from step 2 and paint the next line of trees and bushes. For the trunks use thin Burnt Umber. Mix several greens with various combinations of Hooker's Green Permanent Hue, Light Blue Permanent and Titanium White. Paint the distant grasses with short, vertical strokes of the ⅛-inch (3mm) flat. Add patches of yellow grass with Naples Yellow Hue + a touch of Titanium White.

*4. **Midground Bushes and Grass**.* Lay in the bushes with Sap Green Permanent and the ¼-inch (6mm) flat. Dilute the Sap Green Permanent with water for the loose leaves at the edges. Paint more grass as you did in step 3. The lighter, brighter grass is Brilliant Yellow Green + a touch of Titanium White.

5. Midground Bushes. With the ⅛-inch (3mm) flat, pat in some more bushes with Sap Green Permanent. Mix Hooker's Green Permanent Hue + Titanium White (1:1) and slip-slap some midtone leaves with the ⅛-inch (3mm) flat. Glaze a mix of Ultramarine Blue + Hooker's Green Permanent Hue (2:1) for shading in some areas of the bushes. Paint the lightest leaves with Brilliant Yellow Green.

6. Midground Flowers. Tap in the pink flowers on the bushes with Raspberry + Titanium White (2:1) and the ⅛-inch (3mm) flat. Add more Titanium White for highlights. Mix Ultramarine Blue + Titanium White (2:1) and tap in the blue flowers, using the edge of the ⅛-inch (3mm) flat. Use Hooker's Green Permanent Hue for the leaves.

7. Stone Wall. Add more Titanium White to the blue flower mixture from step 6 and dot in highlights with the no. 1 round. Retransfer the walls if necessary. Using the ¼-inch (6mm) flat, basecoat the walls with Payne's Gray + Titanium White + Raw Umber (1:1: touch). When that's dry, transfer the lines between the stones with white transfer paper.

8. Wall and foliage. Mix Raw Umber + Payne's Gray (2:1) and paint the stone lines with the no. 1 round. Add foliage behind the left-hand wall with Sap Green + a generous touch of Ultramarine Blue using horizontal strokes of the chisel edge of the ¼-inch (6mm) flat. Paint the Raspberry + Titanium White flowers as you did in step 6. Paint the branches Raw Umber + Titanium White (1:1).

9. Stone Wall. Mix Raw Umber + Naples Yellow Hue + Titanium White (1:1:1) and paint texture on the stones by making scribbling strokes with the ⅛-inch (3mm) flat. Glaze shading on each stone with thin Raw Umber and the ¼-inch (6mm) flat. The step 9 photo shows this in progress. The stones on the left have been textured only, while the stones on the right have been textured and glazed.

10. Stone Wall. Glaze some of the stones with Raw Sienna and some with Sap Green Permanent. Highlight by adding more Titanium White to the Raw Umber + Naples Yellow + Titanium White mixture from step 9.

11. Distant Sheep. Transfer the distant sheep. Paint the sheep bodies with Titanium White + a touch of Naples Yellow Hue and the no. 1 round. Their heads and legs are painted with Raw Umber + a touch of Payne's Gray. Shade with glazes of Raw Umber. Glaze shadows under the sheep with Sap Green Permanent + a touch of Ultramarine Blue. Add more grass around them with thin Sap Green Permanent using the ⅛-inch (3mm) flat.

12. Midground Grass. Add a hint of a stone wall behind the blue flowers, if desired. Use the ¼-inch (6mm) flat to paint the midground grass as you did in step 3, but make your brushstrokes larger. Use various combinations of Hooker's Green Permanent Hue, Titanium White, Brilliant Yellow Green, Naples Yellow Hue and Raw Sienna.

13. Foreground Grass. For the foreground grass, use the ¼-inch (6mm) grass comb/rake and paint the grass strokes with some of the lighter green mixes. If the grasses look chalky, glaze over the green grass with Hooker's Green Permanent Hue and the yellow grass with Raw Sienna. Use the ⅛-inch (3mm) flat to slip-slap some foliage overlapping the stone walls with Sap Green Permanent.

TIP

Plain Titanium White can look cold and gray after it dries, so I like to add a slight touch of Naples Yellow Hue, Yellow Ochre or Raw Sienna to warm it up a little.

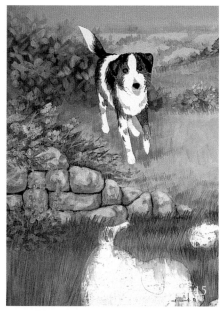

14. Flowers. Paint the pink flowers overlapping the wall as you did in step 6. Mix Hooker's Green Permanent Hue + Titanium White (1:1) and paint the leaves for the blue flowers with the ⅛-inch (3mm) flat. For the stems, use the chisel edge of the brush. Tap in the blossoms with Ultramarine Blue + a generous touch of Titanium White.

15. Flowers and Mother Dog. Mix Ultramarine Blue + Raspberry (1:1); dilute with water, and shade the blue flowers. Dot Naples Yellow Hue in the centers with the no. 1 round. Remove the mask from the mother dog. Mix Raw Umber + Payne's Gray (2:1); dilute with water, and paint the dark patches on the dog as shown, using the no. 2 round. Paint the eyes with Burnt Umber and the tongue with Titanium White + Cadmium Red Medium Hue (2:1).

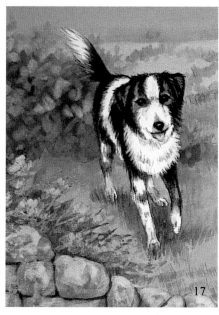

16. Mother Dog. Build up the dark fur with Ivory Black and the no. 1 round. Mix Titanium White + Ivory Black (3:1) for the highlights in the black fur. Shade the white fur with glazes of Raw Umber. Highlight the eyes and nose with Titanium White.

17. Mother Dog. Add delicate details to the dog with thin Raw Umber and the no. 1 round. Paint white hair overlapping the dark hairs with Titanium White. Use Sap Green Permanent to paint some grass overlapping the paws. Shade the tongue with a glaze of Raw Umber.

18. Puppies. Uncover the puppies. Paint the dark patches on the puppies with Raw Umber and the no. 4 round and paint the eyes with Burnt Umber. Begin shading the white areas with very thin Raw Umber.

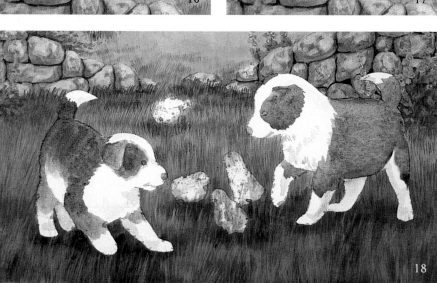

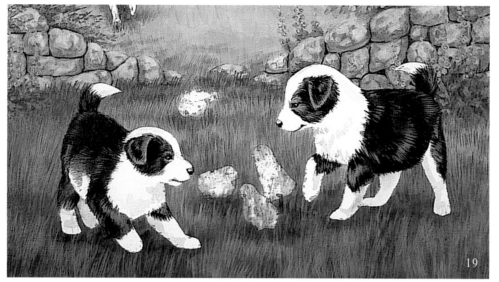

19. Puppies. Shade and highlight the dark fur on the puppies as you did for their mother in steps 15 and 16. Build up the fur with delicate strokes of the no. 1 round, following the direction of hair growth. Add highlights to the eyes and noses with dots of Titanium White.

20. Puppies and Chicks. Add delicate details to the puppies and white hair overlapping the dark hairs as you did in step 17. Use Sap Green Permanent to paint some grass overlapping the paws. Uncover the chicks. Basecoat them with Cadmium Yellow Medium Hue + a touch of Titanium White.

21. Chicks. Transfer the chicks' legs with the white transfer paper. Paint them with the no. 1 round and Raw Sienna + a touch of Titanium White. Shade the chicks with the same mixture and for their eyes use Raw Umber.

22. Chicks. Mix Titanium White + Naples Yellow Hue (2:1) and paint the light feathers on the chicks, still using the no. 1 round. Detail with thin Raw Umber. Glaze thin Naples Yellow Hue over the chicks to soften the feathers. Add blades of grass around the feet with the green mixture from step 12. Finally, add the foreground rocks, as you did the stone wall in steps 8-10.

Peekaboo Piglets

A FEW YEARS AGO I took a vacation to Vermont. I had to stop and take pictures of the attractive little farm that serves as this painting's background. I tried to capture the mischievous look of the little piglets that have gone out exploring away from Mama's watchful eye!

MATERIALS LIST

Surface
9" × 12" (23cm × 30cm) Canson Montval acrylic paper 148lb (315gsm)

Brushes
¾-inch (19mm) flat

⅛-inch (3mm) and ¼-inch (6mm) one-stroke flat

nos. 1 and 4 rounds

⅛-inch (3mm) and ¼-inch (6mm) grass comb/rake (homemade or purchased, see page 12)

Liquitex Soft Body Artist Acrylic Colors
Alizarin Crimson Hue Permanent, Brilliant Purple, Brilliant Yellow Green, Burnt Umber, Hooker's Green Permanent Hue, Light Blue Permanent, Light Portrait Pink, Medium Magenta, Naples Yellow Hue, Payne's Gray, Raw Sienna, Raw Umber, Red Oxide, Titanium White, Ultramarine Blue (Red Shade)

Additional Materials
Foamcore board

Sharp craft knife

Masking film or fluid

Wet palette

Water in a container

Drafting tape (*not* masking tape)

Sharp pencil or stylus

Graphite transfer paper

White transfer paper

Tracing paper

Small sea sponge

Pattern. This pattern may be hand-traced or photocopied for personal use only. Enlarge at 152% on a photocopier to bring it up to full size.

COLOR MIXTURES

Light Portrait Pink + Red Oxide (1:1)

Red Oxide + Burnt Umber (1:1)

Brilliant Yellow Green + Hooker's Green Permanent Hue + Titanium White (2:1:1)

Hooker's Green Permanent Hue + Brilliant Yellow Green (2:1)

Hooker's Green Permanent Hue + Light Blue Permanent (1:1)

Hooker's Green Permanent Hue + Ultramarine Blue (1:1)

Ultramarine Blue + Hooker's Green Permanent Hue (2:1)

Brilliant Purple + Light Blue Permanent + Titanium White (1:1: touch)

Light Blue Permanent + Ultramarine Blue + Medium Magenta (1:1: generous touch)

Payne's Gray + Hooker's Green Permanent Hue (2:1)

Light Blue Permanent + Ultramarine Blue (1:1)

Payne's Gray + Light Blue Permanent (1:1)

Alizarin Crimson Hue Permanent + Ultramarine Blue (1:1)

Raw Umber + Payne's Gray (1:1)

1

2

PREPARE FOR PAINTING

Use drafting tape to tape the acrylic paper on all four sides to the foamcore support, leaving an 8" × 10" (20cm × 25cm) area for painting. Trace and transfer the design, except the background cows and horse, and the foreground flowers. Use masking film or masking fluid to protect the barn, house, pigs and fence as instructed on pages 14-15. (If you use masking fluid, you will need to reapply it to the pigs after you uncover the fence in step 13.)

1. Sky. Wet the sky area with clean water and the ¾-inch (19mm) flat. Mix Light Blue Permanent + Ultramarine Blue (2:1), and paint a wash across the top of the sky, letting it fade into the clean water at the bottom. Painting a graduated wash takes a little practice, so you may want to try it on a spare sheet of paper first.

3

4

2. Distant Mountains and Grass. Add a generous touch of Medium Magenta to the sky mixture from step 1, and paint the distant mountains. Let dry. Wet the ground area with clean water. Mix Light Blue Permanent + Hooker's Green Permanent Hue (1:1) and paint the distant grass. For the foreground grass mix Hooker's Green Permanent Hue + Brilliant Yellow Green (2:1). Add more Hooker's Green Permanent Hue for the grassy area by the fence.

3. Distant Trees. Brush mix some Hooker's Green Permanent Hue into the sky mixture from step 1 and paint the distant tree line with the ¼-inch (6mm) flat. Mix a medium green with Hooker's Green Permanent Hue + Titanium

White (2:1), and a dark green with Hooker's Green Permanent Hue + Ultramarine Blue (1:1). Paint loose tree shapes with the ⅛-inch (3mm) flat. Add more trees with Naples Yellow Hue and Red Oxide. The photo shows this in progress.

4. Distant Trees and Midground Grasses. Help the background trees recede by glazing very thin Titanium White over the top. Mix several greens with various combinations of Hooker's Green Permanent Hue, Ultramarine Blue, and Titanium White. Paint the midground grasses with short, vertical strokes of the ⅛-inch (3mm) flat. Add patches of yellow grass with Naples Yellow Hue.

TIP

The sky always gets lighter toward the horizon, so being able to paint a graduated wash is a useful skill. Also, in order to make the ground appear to recede into the distance, it is helpful to mix a little of the sky color into your ground color. The foreground should be darker and brighter than the background.

5

6

7

8

5. Midground Trees. With a damp sea sponge, tap in the tree shapes by the barn and house with Naples Yellow Hue. Add touches of Hooker's Green Permanent Hue and Red Oxide. Draw in trunks and branches with Raw Umber and the no. 1 round. Add the back fence by the barn with Titanium White + a slight touch of Raw Umber.

6. House. Remove the mask from the house. Mix Payne's Gray + Light Blue Permanent (1:1), and paint the roof with the no. 1 round. Highlight with Titanium White, and shade with glazes of Payne's Gray. Use Raw Umber for the windows and for the door use Red Oxide. Let dry thoroughly, then glaze the whole house with thin Naples Yellow Hue.

7. Barn and Distant Fence. Unmask the barn. Using the no. 4 round, paint the barn roof as you did the house roof in step 6. Paint the barn's

sides Red Oxide; shade with Payne's Gray. Render the windows and door with Raw Umber. Detail with Titanium White and the no. 1 round. Finish painting the fence, using the same mixture and brush you used in step 5.

8. Path and Grass. Indicate the path under the pigs with diluted Raw Umber and the ¾-inch (19mm) flat brush. Using the ¼-inch (6mm) grass comb/rake, fill in the grass behind the pigs with the color mixtures from step 4. Add some Brilliant Yellow Green + a generous touch of Titanium White for the lightest areas. Your strokes should get longer as you move down the page.

9. Bushes and Path. Brush mix Ultramarine Blue + Hooker's Green Permanent Hue (2:1) and paint the loose bush shapes around the fence with the ¼-inch (6mm) flat. Switch to the ⅛-inch (3mm) flat, and paint bushes around the house with the same mix. Mix Raw Umber + Titanium White (2:1), and add the path. Drybrush a little of that path mixture across the front of the house.

10. House and Path. With the no. 1 round, paint shutters on the windows with the roof mixture from step 6. Add another bush with Red Oxide. Highlight the bushes with a mix of Hooker's Green Permanent Hue + Brilliant Yellow Green + Titanium White (1:1:1). Mix Medium Magenta + Light Blue Permanent (1:1) and dot little flowers on the bushes. Add more Titanium White to the path mixture from step 9 and paint lighter patches on the path. Then paint darker streaks with Raw Umber.

11. Leaves. Mix several greens from Hooker's Green Permanent Hue and various amounts of Titanium White. Paint leaves on the bushes with the ⅛-inch (3mm) flat. Let dry. Glaze over the top with thin Hooker's Green Permanent Hue. Add delicate Raw Umber branches with the no. 1 round. Mix Raw Umber + a touch of Titanium White and paint the path with slip-slap horizontal strokes, using the ¼-inch (6mm) flat. Add more Titanium White (1:1), and paint more slip-slaps over the top.

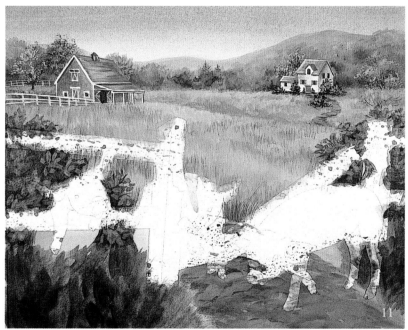

12. Distant Horse and Cows. Transfer the horse and cows with white transfer paper. Basecoat the distant animals with Titanium White and the no. 1 round. Shade the horse with Raw Umber + a generous touch of Titanium White. Paint patches on the cows with Burnt Umber + Titanium White (2:1) and shade with diluted Raw Umber. Paint shadows under all the distant animals with Hooker's Green Permanent Hue + Ultramarine Blue.

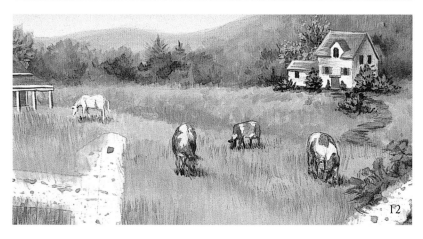

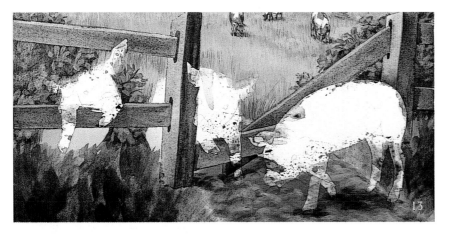

13. Near Fence and Path. Add more foliage behind the fence using the green mixtures from step 11, if desired. Glaze the path with Raw Sienna. Remove the mask from the fence (remask the piglets if you used masking fluid). Mix Raw Umber + Payne's Gray (1:1), dilute with water until quite thin, then basecoat the fence with the no. 4 round. Shade the fence with more glazes of that mixture, still using the no. 4 round.

Switch to the ⅛-inch (3mm) flat, and paint the shadows under the pigs with Raw Umber. Mix Titanium White + Raw Sienna (2:1), and paint light "lumps" on the path. Glaze over the top of the path with Raw Umber at the edges and Raw Sienna down the center.

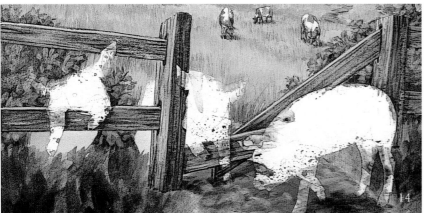

14. Fence. Mix more Raw Umber + Payne's Gray, but use less water so the mixture is thicker and darker. Paint the wood grain on the fence with the no. 1 round. Next, add Titanium White to the fence mixture (3 parts Titanium White :1 part fence mixture). Drybrush this mixture onto the fence to add texture and to highlight.

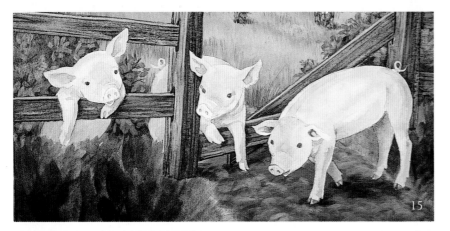

15. Pigs. Remove the mask from the pigs. Basecoat them with Light Portrait Pink, using the no. 4 round. Use Burnt Umber for the eyes. Begin shading with thin glazes of Burnt Umber.

16. Pigs. With the ⅛-inch (3mm) grass comb/rake, paint Titanium White fur strokes on the pigs. Their pink skin should show through, as their hair is rather sparse. Their legs and tummies are less hairy, so glaze Titanium White highlights in those areas with the no. 4 round.

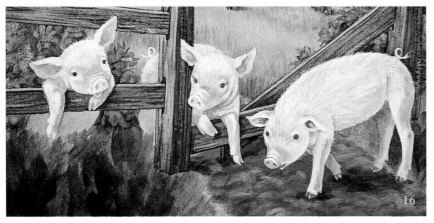

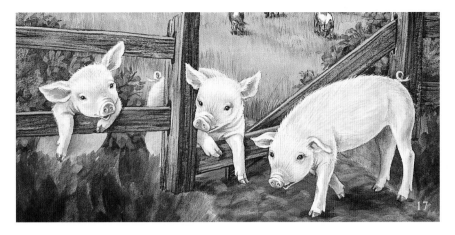

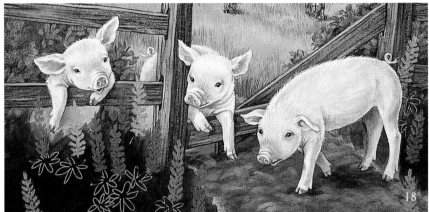

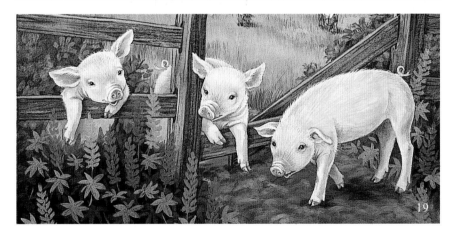

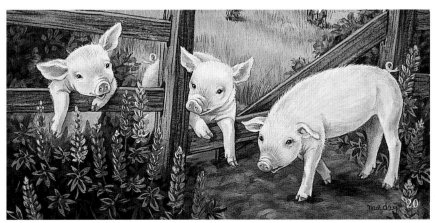

17. Pigs. Mix Light Portrait Pink + Red Oxide (1:1) and glaze the reddish areas on the faces with the no. 1 round. Mix Red Oxide + Burnt Umber (1:1), dilute with water until quite thin, then add the darks, still using the no. 1 round. Make the pupils of the eyes Payne's Gray. Dot in white highlights with Titanium White.

18. Flowers. Mix Payne's Gray + Hooker's Green Permanent Hue (2:1) and darken the area where the flowers will go, using the ¼-inch (6mm) flat brush. Transfer the flowers with white transfer paper. With the ⅛-inch (3mm) flat, tap in the blossoms with Medium Magenta on some flowers, and mix Brilliant Purple + Light Blue Permanent + Titanium White (1:1) for the others.

19. Flowers. Mix Hooker's Green Permanent Hue + Titanium White (2:1) and paint leaves with the ¼-inch (6mm) flat. Paint the stems with the chisel edge of the brush. Let dry, then glaze over the top with thin Hooker's Green Permanent Hue. Brush mix Brilliant Yellow Green + Hooker's Green Permanent Hue + Titanium White (2:1:1), and paint lighter leaves over the top.

20. Flowers. Shade the lightest leaves with Hooker's Green Permanent Hue and the no. 1 round. Mix Ultramarine Blue + Alizarin Crimson Hue Permanent (1:1); dilute with water, and shade the purple flowers. Shade the magenta flowers with plain Alizarin Crimson Hue Permanent. Highlight with Titanium White. Finally, glaze a little Ultramarine Blue over the bushes behind the fence with the ¼-inch (6mm) flat.

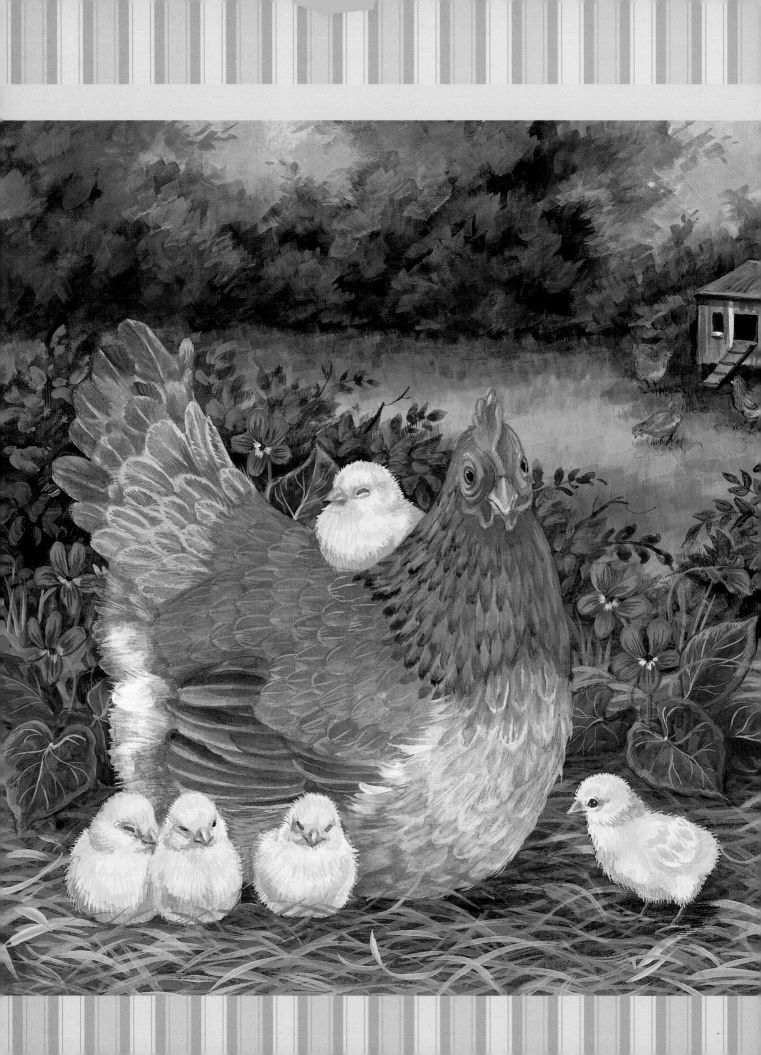

Down Comforter

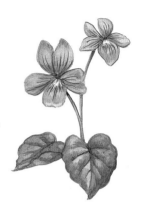

IS THERE ANYTHING SOFTER than a baby chick? In this painting I tried to convey the warmth of a mother's embrace at nap time. I used mostly warm colors in the foreground to draw your eye to that area, and I balanced that with cooler colors in the background.

MATERIALS LIST

Surface
9" × 12" (23cm × 30cm) Canson Montval acrylic paper 148lb (315gsm)

Brushes
¾-inch (19mm) flat

⅛-inch (3mm) and ¼-inch (6mm) one-stroke flat washes

nos. 1, 2 and 4 rounds

Liquitex Soft Body Artist Acrylic Colors
Brilliant Purple, Brilliant Yellow Green, Burnt Umber, Cadmium Red Medium Hue, Cadmium Yellow Medium Hue, Hooker's Green Permanent Hue, Naples Yellow Hue, Payne's Gray, Raw Sienna, Raw Umber, Sap Green Permanent, Titanium White, Ultramarine Blue (Red Shade)

Additional Materials
Foamcore board

Sharp craft knife

Masking film or fluid

Wet palette

Water in a container

Drafting tape (*not* masking tape)

Sharp pencil or stylus

Graphite transfer paper

White transfer paper

Tracing paper

Pattern. This pattern may be hand-traced or photocopied for personal use only. Enlarge at 152% on a photocopier to bring it up to full size.

COLOR MIXTURES

Raw Sienna + Burnt Umber (2:1)

Cadmium Yellow Medium Hue + Naples Yellow Hue (2:1)

Naples Yellow Hue + Hooker's Green Permanent Hue (2:1)

Brilliant Yellow Green + Hooker's Green Permanent Hue + Titanium White (1:1:1)

Hooker's Green Permanent Hue + Ultramarine Blue (1:1)

Hooker's Green Permanent Hue + Raw Umber (1:1)

Sap Green Permanent + Payne's Gray (1:1)

Payne's Gray + Titanium White + Ultramarine Blue (1:1:1)

Raw Umber + Payne's Gray (2:1)

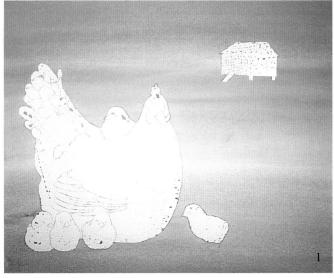

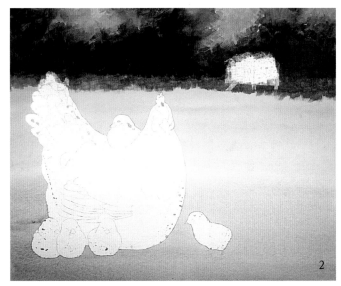

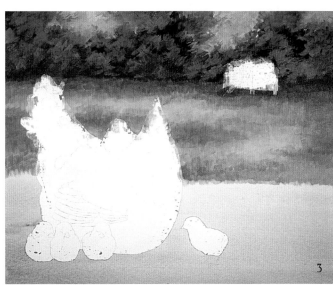

PREPARE FOR PAINTING

Use drafting tape to tape the acrylic paper on all four sides to the foam-core support, leaving an 8" × 10" (20cm × 25cm) area for painting. Trace and transfer the design, except for the violets and distant hens. Cover the foreground hen and chicks and the henhouse with masking film or fluid.

1. Sky, Midground and Foreground. With the ¾-inch (19mm) flat, dampen the entire painting surface with clean water. While the paper is still wet, paint the sky area with a mixture of Titanium White + Ultramarine Blue (2:1), diluted with water. Use a thin wash of Sap Green Permanent for the midground, and use Raw Umber for the foreground.

2. Background Foliage. Mix Sap Green Permanent + Payne's Gray (1:1) and paint the background foliage with the ¼-inch (6mm) flat, leaving some sky showing through. Soften the edges around the sky with more of the sky mixture from step 1. Soften the edge of the grass where it

meets the bushes, using Hooker's Green Permanent Hue + Raw Umber (1:1) and short, vertical strokes of the ¼-inch (6mm) flat.

3. Grass and Foliage. Continue painting the grass with various greens mixed from Hooker's Green Permanent Hue, Naples Yellow Hue and Brilliant Yellow Green. Switch to the ⅛-inch (3mm) flat, and paint lighter foliage in the background with Sap Green Permanent + Titanium White (1:1). If the color looks chalky, glaze Sap Green Permanent over the top.

4. Foliage, Bushes and Foreground. Add the lightest foliage to the background with Brilliant Yellow Green. Block in the bushes behind the hen with the background foliage mixture from step 2 and the ¼-inch (6mm) flat. Paint the foreground with the ¾-inch (19mm) flat and Raw Umber + Payne's Gray (2:1).

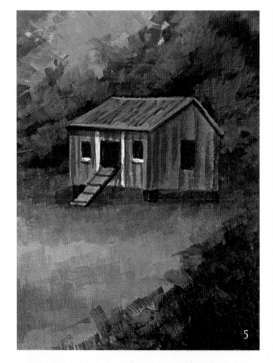

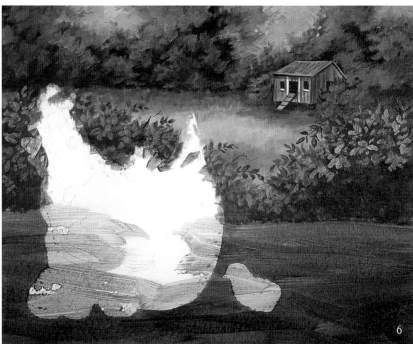

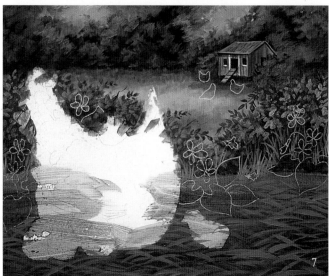

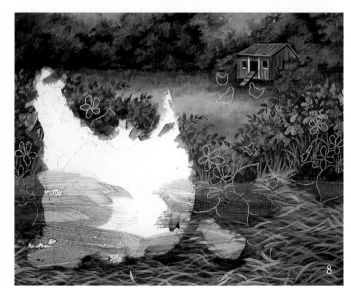

5. Henhouse. Remove the mask from the henhouse. Mix Payne's Gray+ Titanium White + Ultramarine Blue (1:1:1), and paint the henhouse with the no. 4 round. Paint the windows with Payne's Gray and the ramp with Raw Umber. For the roof use the foreground mixture from step 4.

Switch to the no. 2 round, and shade the house with glazes of Payne's Gray. Detail the door and windows with Titanium White and the no. 1 round. Add streaks of Titanium White + Raw Umber (2:1) to the roof. Add more details to the roof and ramp with the foreground mixture. Add streaks of Payne's Gray to the henhouse.

6. Bushes. Using the ⅛-inch (3mm) flat, paint bushes beside the henhouse in the same manner as you did in the background. Glaze Raw Umber in front.

With the no. 1 round, add twigs on the bushes behind the hen with the Raw Umber + Payne's Gray mixture. Paint leaves on the twigs with

the Hooker's Green/Raw Umber mixture from step 2. With the ⅛-inch (3mm) flat, paint leaves all over the front bushes with various mixtures of Hooker's Green Permanent Hue, Brilliant Yellow Green and Raw Umber.

7. Violets, Grass and Straw. Use white transfer paper to transfer the violets and distant hens. With the no. 4 round, paint grass with Hooker's Green Permanent Hue + Titanium White (2:1). Add some Naples Yellow Hue grass over the top. Begin laying in straw with Raw Sienna + a touch of Titanium White.

8. Straw. Paint more straw with Naples Yellow Hue, then with Naples Yellow Hue + Titanium White (1:1). Paint a little greenish straw with Naples Yellow Hue + Hooker's Green Permanent Hue (2:1). Glaze shading under the mother hen and her chicks with the Raw Umber + Payne's Gray mixture from step 6.

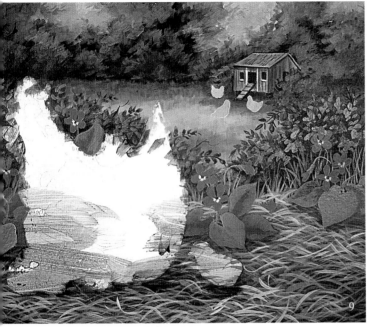

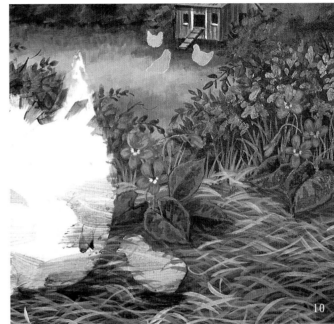

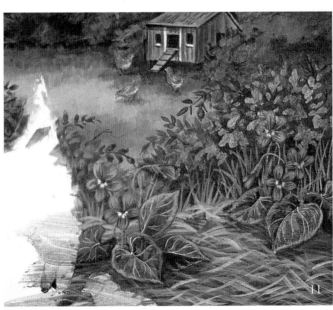

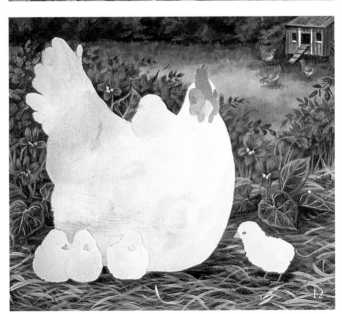

9. *Violets and Distant Hens*. Still using the no. 4 round, basecoat the violet leaves with Hooker's Green Permanent Hue + a touch of Titanium White. Paint the flowers with Brilliant Purple + Ultramarine Blue (2:1). Mix Titanium White + Raw Sienna (2:1) and paint the hens in the background.

Mix Brilliant Yellow Green + Hooker's Green Permanent Hue + Titanium White (1:1:1) and paint the lighter areas of the leaves. Use the same mixture for the stems. Switch to the no. 1 round, and dot Payne's Gray in the centers of the violets. When that is dry, paint a little Titanium White around the flower centers, as shown in the photo.

10. *Violets*. Mix Hooker's Green Permanent Hue + Ultramarine Blue (1:1) and paint the darks on the leaves with the no. 4 round. Let dry, then glaze pure Ultramarine Blue over some areas. Add Titanium White to the violet flower basecoat mixture from step 9, and paint the light areas on the flowers.

11. *Violets and Distant Hens*. Mix Ultramarine Blue + a touch of Payne's Gray and paint the details on the flowers with the no. 1 round. Paint the light details on the leaves with Brilliant Yellow Green + a touch of Titanium White.

Shade the distant hens with Raw Umber, and glaze a little Raw Sienna over the top. Shade underneath them with the Hooker's Green/Raw Umber mix from step 2.

12. *Hen and Chicks*. Remove the mask from the hen and chicks. Dilute Raw Sienna until quite thin, and basecoat the hen. For the comb and wattle use a mixture of Cadmium Red Medium Hue + a touch of Naples Yellow Hue, and the no. 4 round. (Add red combs to the background hens, too.) Paint the eyes with Raw Umber. For the chicks use Naples Yellow Hue + a touch of Titanium White. The beaks and legs are Naples Yellow Hue + a generous touch of Cadmium Red Medium Hue.

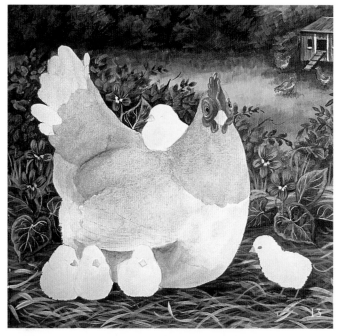

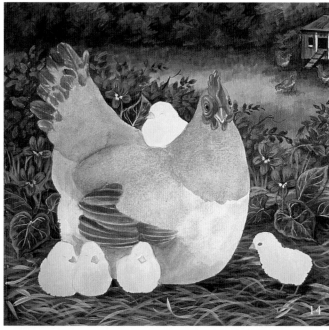

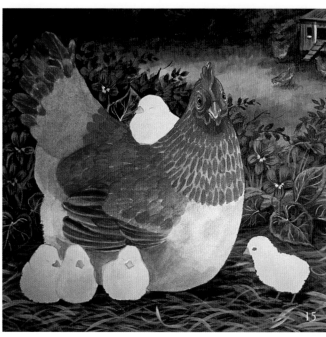

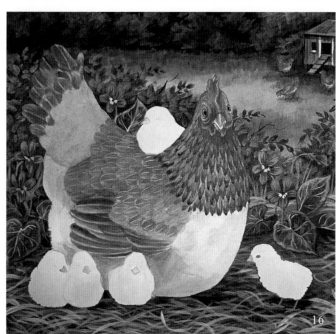

13. Hen. Shade the hen with glazes of Raw Umber, using the no. 4 round. Add another glaze of Raw Sienna on the head, back and wing. Shade the comb and wattle with Burnt Umber. Using the no. 1 round, add a Payne's Gray pupil to each eye and highlight with Titanium White.

14. Hen. Detail the beak with Raw Umber and highlight with Titanium White, using the no. 1 round. Add more of the beak mixture from step 12 if the beak seems too pale. Use the no. 4 round to detail the wing and tail feathers with the Raw Umber + Payne's Gray mixture from step 4, diluted with water until transparent. Glaze Raw Sienna over the top.

15. Hen. Mix Raw Sienna + Burnt Umber (2:1). Paint the neck and body feathers with the no. 4 round. Paint a row of round feathers, let dry, then paint the next row overlapping the first. Shade with glazes of Burnt Umber.

16. Hen. Detail the neck feathers with the Raw Umber + Payne's Gray mixture from step 4 and the no. 2 round. Mix Titanium White + a generous touch of Raw Sienna and add light feather details with the no. 1 round. When that is dry, glaze with Raw Sienna.

17. Hen. Paint the light feathers with the no. 4 round and the Titanium White + Raw Sienna mixture from step 16. Shade with thin glazes of the Raw Umber + Payne's Gray mixture from step 4. Soften the feathers on the neck with light touches of Titanium White + Raw Sienna (2:1). Let dry, then glaze over the top with thin Raw Sienna.

18. Hen. Glaze Raw Sienna over the white feathers, except for the feathers on the hen's bottom. Paint details with the feather mixture from step 15. Add more details with Titanium White. Bring some of the light feathers up over the darker neck feathers, as shown, by basecoating with the Titanium White + a touch of Raw Sienna mixture from step 16, then adding details as before.

19. Chicks. Using the no. 2 round, shade the chicks with diluted Raw Umber, blending with clean water while it is still wet. Paint the eyes with the Raw Umber + Payne's Gray mixture from step 4 and the no. 1 round. Add more shading to the beaks with more of the beak mixture from step 14. Highlight with Titanium White.

20. Chicks and Final Details. Mix Titanium White + a generous touch of Naples Yellow Hue and paint delicate, downy feathers on the chicks with the no. 1 round. Glaze a mixture of Cadmium Yellow Medium Hue + Naples Yellow Hue (2:1) over some of the lighter feathers, as shown. Finally, paint a few pieces of straw overlapping the hen and chicks.

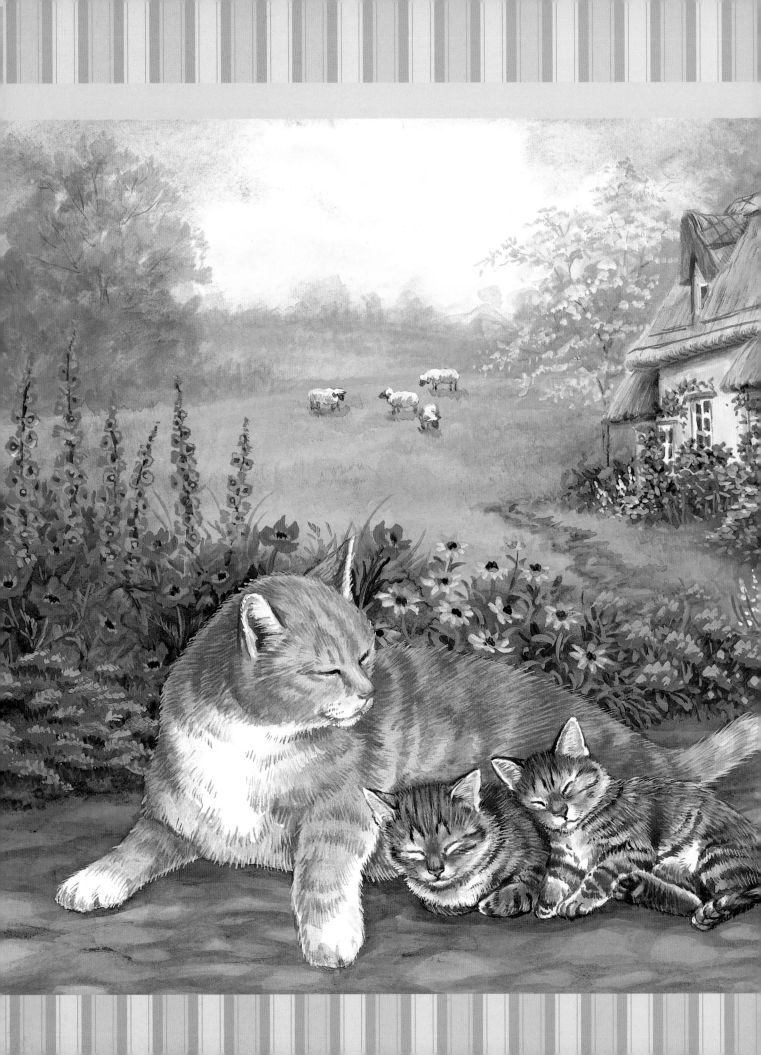

All Tuckered Out

FLOWERS ARE FUN TO PAINT, especially if you don't try to paint them too tightly. The goal in this painting is to create a peaceful, idyllic scene—"purrfect" for two sleepy kittens!

MATERIALS LIST

Surface

9" × 12" (23cm × 30cm) Canson Montval acrylic paper 148lb (315gsm)

Brushes

½-inch (12mm) flat

⅛-inch (3mm) and ¼-inch (6mm) one-stroke flat washes

no. 2 round

⅛-inch (3mm) and ¼-inch (6mm) grass comb/rake (homemade or purchased, see page 12)

Liquitex Soft Body Artist Acrylic Colors

Brilliant Yellow Green, Burnt Sienna, Cadmium Red Medium Hue, Hooker's Green Permanent Hue, Light Blue Permanent, Naples Yellow Hue, Olive, Payne's Gray, Raw Sienna, Raw Umber, Red Oxide, Titanium White, Ultramarine Blue (Red Shade)

Additional Materials

Foamcore board

Sharp craft knife

Masking film or fluid

Wet palette

Water in a container

Drafting tape (*not* masking tape)

Sharp pencil or stylus

Graphite transfer paper

White transfer paper

Tracing paper

Facial tissue

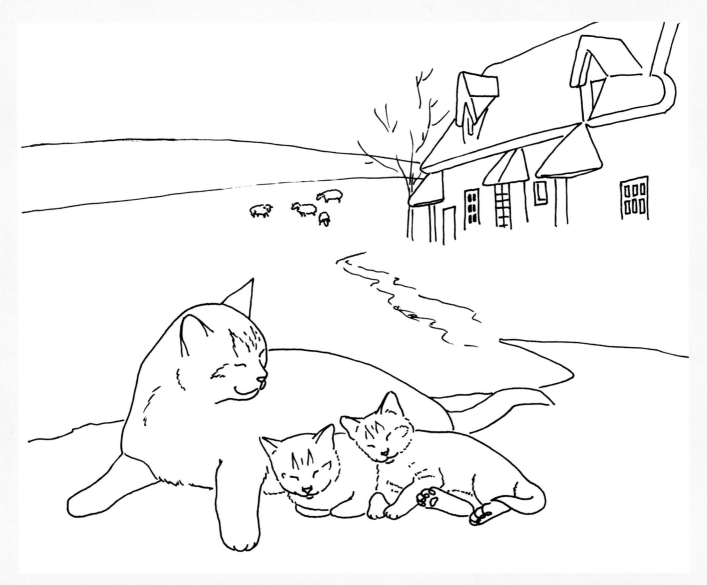

Pattern. This pattern may be hand-traced or photocopied for personal use only. Enlarge at 152% on a photocopier to bring it up to full size.

COLOR MIXTURES

Light Portrait Pink + Red Oxide (2:1)

Cadmium Red Medium Hue + Naples Yellow Hue (2:1)

Raw Umber + Raw Sienna (1:1)

Burnt Sienna + Raw Sienna (1: touch)

Olive + Brilliant Yellow Green + Titanium White (2:1:1)

Brilliant Yellow Green + Light Blue Permanent (1:1)

Payne's Gray + Hooker's Green Permanent Hue (1:1)

Ultramarine Blue + Light Blue Permanent (1:1)

PREPARE FOR PAINTING

Use drafting tape to tape the acrylic paper on all four sides to the foamcore support, leaving an 8" × 10" (20cm × 25cm) area for painting. Trace and transfer the design, except for the flowers and distant sheep. Cover the cat and kittens with masking film or masking fluid. (If you use masking fluid, you will need to remask the kittens after you unmask the cat in step 17.)

1. Sky. Wet the sky area with clean water and the ½-inch (12mm) flat. While it is still wet, paint in Ultramarine Blue, diluted with water, letting it blend into the wet paper to create clouds. If necessary, you can lift out the clouds with a tissue (see page 23). Let dry thoroughly, then wet the cloud area again. Paint washes of Light Portrait Pink and Naples Yellow Hue, still using the ½-inch (12mm) flat.

2. Distant Fields. Mix Brilliant Yellow Green + Light Blue Permanent (1:1) and paint a thin wash across the distant background. When that's dry, switch to the ¼-inch (6mm) flat, and paint loose tree shapes along the horizon with the same mixture. Add some very thin glazes of Brilliant Purple to the trees. Add more Brilliant Yellow Green to the distant grass mixture and paint the midground grass with the ½-inch (12mm) flat.

3. Distant Trees. Add touches of Ultramarine Blue and Titanium White to the grass mixture from step 2 and paint more loose foliage with the ¼-inch (6mm) flat. Paint a few short vertical strokes across the most distant grass to add texture with the same mixture. Add a few more strokes to the grass with very thin Naples Yellow Hue.

4. Path and Foliage. Paint the path with a thin wash of Raw Umber, using the ½-inch (12mm) flat. Mix Olive + Brilliant Yellow Green + Titanium White (2:1:1) and paint the distant tree foliage with the ⅛-inch (3mm) flat. Make sure some sky shows through. Add a little Ultramarine Blue to the mixture for the darker foliage. Add another bush with very thin Red Oxide. Draw in a few delicate branches with diluted Raw Umber and the no. 0 round.

5. Cottage and Foreground Foliage. Paint the thatched roof with diluted Raw Umber and the ¼-inch (6mm) flat. For the house use Light Portrait Pink + Red Oxide (2:1) diluted with water. Darken the greens around the house and cat with washes of Payne's Gray + Hooker's Green Permanent Hue (2:1), still using the ¼-inch (6mm) flat.

6. Cottage. Add texture to the house with the ⅛-inch (3mm) flat. Slip-slap strokes of Titanium White + Light Portrait Pink (2:1), pure Light Portrait Pink, and Titanium White + Naples Yellow Hue (2:1). Add shading with glazes of Raw Umber. Shade the roof with Raw Umber + Raw Sienna (1:1). Paint the windows with Payne's Gray and the no. 2 round.

7. Cottage and Tree. Mix Raw Sienna + Titanium White (2:1) and paint the tree beside the house with the no. 2 round. Use the same mixture to add a layer of thatch to the roof with the ¼-inch (6mm) grass comb/rake.

Paint another layer of thatch over the top with Titanium White + a generous touch of Raw Sienna. Touch up the window frames with Titanium White and the no. 0 round.

8. Details on Cottage. Paint tree leaves with Naples Yellow Hue and the ⅛-inch (3mm) flat. For the lighter leaves use Titanium White + Naples Yellow Hue (2:1) and Brilliant Yellow Green. Add grass with thin Hooker's Green Permanent Hue, Olive, Naples Yellow Hue and Brilliant Yellow Green, using the ¼-inch (6mm) grass comb/rake. Glaze Ultramarine Blue and Raw Sienna onto the roof. Detail the roof and windows with the no. 0 round and thin Raw Umber. Paint the leaves around the house with Olive, and darken areas with Payne's Gray + Hooker's Green Permanent Hue (1:1). Shade the path with thin Raw Umber.

9. Flowers Around Cottage. Mix Hooker's Green Permanent Hue + Titanium White (2:1) and paint more leaves on the house with the no. 2 round. Add more Titanium White, and paint even lighter leaves. Dot blue flowers by the tree with Ultramarine Blue + Light Blue Permanent (1:1) and the ⅛-inch (3mm) flat. Add a little Titanium White to the mixture for highlights.

10. Flowers. Mix Cadmium Red Medium Hue + Naples Yellow Hue (2:1), and paint roses with the no. 2 round. Make sure the roses vary in size. Add Titanium White to the mixture for highlights. Add a touch of Brilliant Purple to the blue flower mixture from step 9 and paint more blue flowers, using the ⅛-inch (3mm) flat. Place more red flowers growing next to the blue ones, and paint Brilliant Purple flower spikes next to the red flowers.

11. Path and Flowers. Add texture to the path with curved strokes of the ¼-inch (6mm) flat and Titanium White + Raw Umber. Reglaze the Raw Umber shading if necessary. Add more flowers as shown in the photo, using the no. 0 round and Brilliant Purple, Titanium White, Naples Yellow Hue, and Ultramarine Blue + a touch of Titanium White.

12. Path and Flowers. Glaze Raw Sienna over some areas of the path with the ¼-inch (6mm) flat. Add texture details with very thin Raw Umber and the edge of the brush. Using the no. 0 round, highlight the flowers by adding Titanium White to their base colors. Add more leaves and stems as you did for the roses around the windows.

13. Flowers Behind Cat. Paint the blue flowers behind the cat with the blue flower mixture from step 9, using the ⅛-inch (3mm) flat. Add red poppies with the Cadmium Red Medium Hue + Naples Yellow Hue mixture from step 10. Dot in the purple flowers with Brilliant Purple, and soften the grassy edge with the Hooker's Green Permanent Hue + Titanium White mixtures from step 9. Paint the yellow blossoms with Naples Yellow Hue and the no. 2 round.

14. Flowers. Paint the leaves and stems as before, using the no. 0 round. Add Ultramarine Blue centers to the blue flowers, and highlight some with Light Blue Permanent, and some with Titanium White + a touch of Ultramarine Blue. Add Titanium White to the red flower mix and paint the centers, then dot Raw Umber into the center of those and the yellow flowers. Detail with touches of Cadmium Red Medium Hue. Highlight the purple flowers with Brilliant Purple + Titanium White (1:1).

15. Flowers and Paths. Dot Naples Yellow Hue into some of the blue blossoms. Continue adding leaves and stems. Glaze very thin Red Oxide in the centers of the yellow flowers, and highlight with Titanium White + a touch of Naples Yellow Hue. Paint more blue and red blooms with the ⅛-inch (3mm) flat, as you did in steps 9 and 10. Extend the path using the same colors you used for the foreground in step 11.

16. Distant Sheep. Transfer the distant sheep. Paint the sheep with Titanium White and the no. 2 round. Shade with thin Raw Umber. Glaze a little Naples Yellow Hue over the top. For their heads use Payne's Gray. Paint shadows under the sheep with Olive.

17. Cat and Tree. Remove the masking film from the cat. (If you used masking fluid, remask the kittens.) Basecoat the cat with thin washes of Raw Sienna and the ¼-inch (6mm) flat.

Paint the branches on the tree next to the cottage with Raw Umber and the no. 2 round.

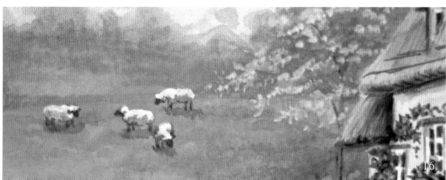

18. Cat and Tree. Paint the cat's eyes and the inside of her ears with Raw Umber and the no. 0 round. Paint the nose and glaze the ear with Red Oxide. Shade the cat with thin glazes of Raw Umber and the no. 2 round. With the ⅛-inch (3mm) flat, tap in foliage on the branches by the house.

19. Cat and Tree. Add lighter leaves to the branches with Brilliant Yellow Green. Mix Burnt Sienna + a touch of Raw Sienna and paint the stripes on the cat with the ⅛-inch (3mm) grass comb/rake.

20. Cat. Use delicate strokes of very thin Raw Umber and the no. 0 round to add details to the face and body. Add white hairs with Titanium White.

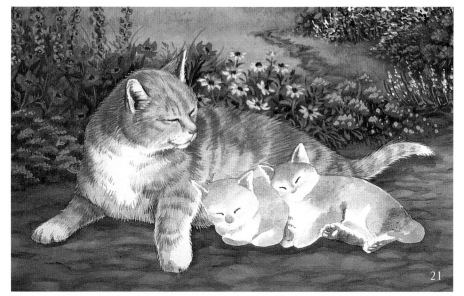

21. Cat and Kittens. Mix Titanium White + Raw Sienna and paint light hairs on the cat's body. Glaze over the top with thin Raw Sienna, if necessary. Remove the mask from the kittens, and basecoat them with thin washes of Raw Umber and the no. 2 round, leaving plain paper for the white areas.

22. Kittens. Paint the noses and mouths and inside the ears with very thin Red Oxide and the no. 0 round. Add the stripes with Raw Umber + Payne's Gray (1:1). Glaze the paw pads with Payne's Gray. Add the mouths with thin Raw Umber.

23. Kittens. Paint delicate little white hairs on the kittens with Titanium White and the ⅛-inch (3mm) grass comb/rake. Glaze Raw Sienna over the top with the no. 2 round. Shade the cat where the kittens touch her, using glazes of Raw Sienna + Raw Umber (1:1).

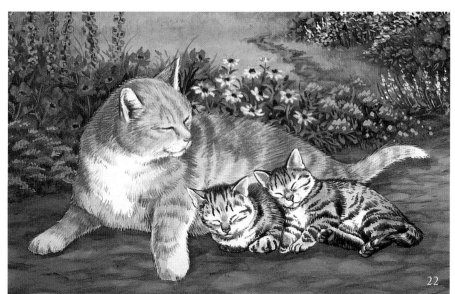

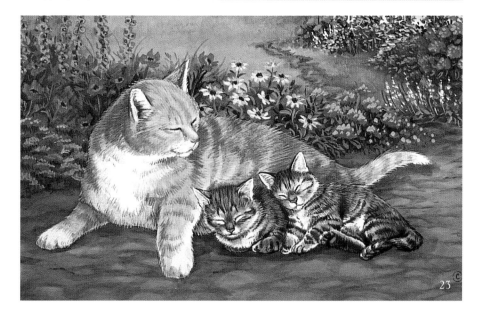

115

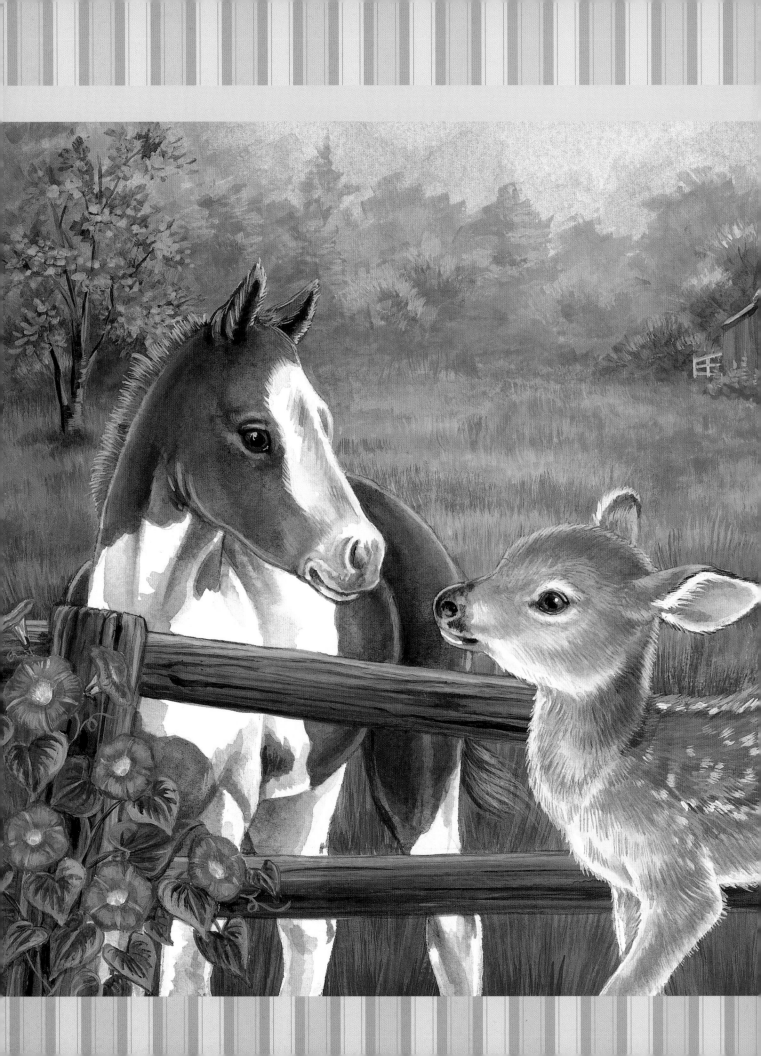

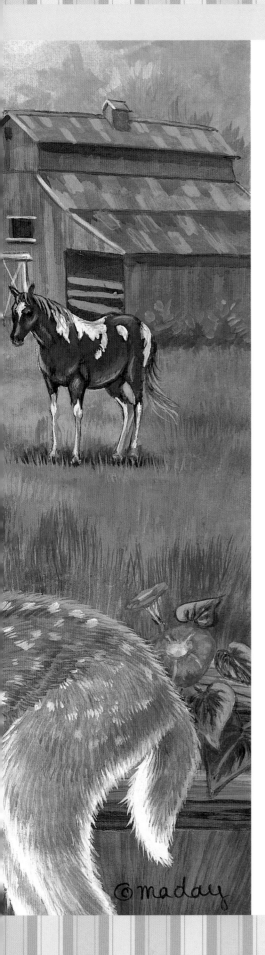

New Neighbors

WE RECENTLY MOVED to a new home. I've watched my children shyly make friends with the neighbors, and it made me wonder if other "new kids" want to make friends too!

MATERIALS LIST

Surface
9" × 12" (23cm X 30cm) Canson Montval acrylic paper 148lb. (315gsm)

Brushes
¾-inch (19mm) flat

⅛-inch (3mm), ¼-inch (6mm) and ½-inch (12mm) one-stroke flat washes

nos. 1 and 4 rounds

¼-inch (6mm) grass comb/rake (home-made or purchased, see page 12)

Liquitex Soft Body Artist Acrylic Colors
Brilliant Purple, Brilliant Yellow Green, Burnt Umber, Light Blue Permanent, Medium Magenta, Naples Yellow Hue, Olive, Phthalocyanine Green, Raw Sienna, Raw Umber, Red Oxide, Sap Green Permanent, Titanium White, Ultramarine Blue (Red Shade)

Additional materials
Foamcore board

Sharp craft knife

Masking film or fluid

Wet palette

Water in a container

Drafting tape (*not* masking tape)

Sharp pencil or stylus

Graphite transfer paper

White transfer paper

Tracing paper

Cotton swabs

Red pastel pencil

Golden brown pastel pencil

Pattern. This pattern may be hand-traced or photocopied for personal use only. Enlarge at 152% on a photocopier to bring it up to full size.

COLOR MIXTURES

| Medium Magenta + Naples Yellow Hue + Light Blue Permanent (2:1: touch) | Olive + Medium Magenta + Naples Yellow Hue + Light Blue Permanent (2:2:1: touch) | Sap Green Permanent + Brilliant Yellow Green (1:1) | Sap Green Permanent + Naples Yellow Hue + Titanium White (1:1:1) | Brilliant Yellow Green + Phthalocyanine Green (2:1) | Sap Green Permanent + Phthalocyanine Green (1:1) |

| Sap Green Permanent + Ultramarine Blue (1:1) | Light Blue Permanent + Medium Magenta (1: touch) | Titanium White + Light Blue Permanent + Brilliant Purple (2:1:1) | Burnt Umber + Ultramarine Blue (1:1) | Raw Umber + Ultramarine Blue (2:1) |

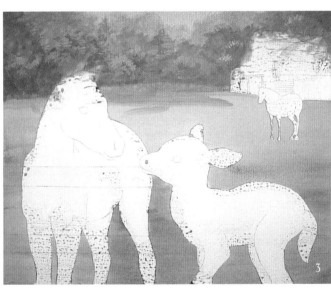

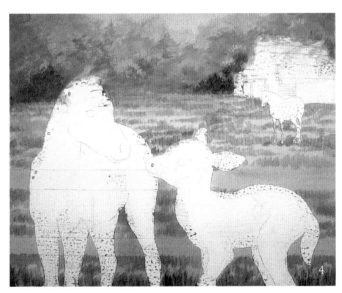

PREPARE FOR PAINTING

Use drafting tape to tape the paper on all four sides to the foamcore support, leaving an 8" × 10" (20cm × 25cm) area for painting. Trace and transfer the design, except the trees and morning glories. You may need to refer to steps 12 and 13 to see the details hidden by the flowers in the pattern. Use masking film or masking fluid to protect the barn, horse, foal and fawn as instructed on pages 14-15. (If you use masking fluid, you will need to reapply it to the horse once you unmask the barn in step 6.)

1. Sky. Wet the sky area with clean water and the ¾-inch (19mm) flat. Brush mix Titanium White + Light Blue Permanent + Brilliant Purple (2:1:1), and paint a wash over the entire sky. Brush mix Medium Magenta + Naples Yellow Hue + Light Blue Permanent (2:1: touch), dilute with water until very transparent, then paint vague tree shapes over the sky with the ½-inch (12mm) flat.

2. Distant Trees. Glaze some very thin Medium Magenta over the top of the tree shapes, and glaze Naples Yellow Hue over the lower part, still using the ½-inch (12mm) flat. Next, add Olive, more Naples Yellow Hue, and Titanium White to the tree mixture from step 1. Paint another line of trees in front, using loose strokes and the ½-inch (12mm) flat.

3. Grass. With the ¾-inch (19mm) flat brush, paint a wash of Sap Green Permanent over the grass. With the ¼-inch (6mm) flat, brush mix Sap Green Permanent + Naples Yellow Hue + Titanium White (1:1:1) and paint a third row of trees. Mix Naples Yellow + Titanium White (1:1), and paint highlights on the foremost trees.

4. Bushes. Brush mix Sap Green Permanent + Phthalocyanine Green (1:1) and paint a couple of bushes with the ¼-inch (6mm) flat. Use the same brush and Sap Green Permanent to begin adding texture to the grass with short, vertical strokes. Glaze a little very thin Phthalocyanine Green in areas of the third row of trees.

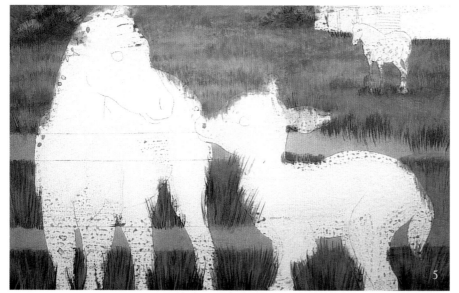

5. Grass. Mix several greens with various combinations of Sap Green Permanent, Naples Yellow Hue, Titanium White, Brilliant Yellow Green and Phthalocyanine Green. Paint the grass with short, vertical strokes and the ¼-inch (6mm) grass comb/rake. The strokes should get longer and the colors should get brighter as you move down the painting. Mix Brilliant Yellow Green + a touch of Titanium White and add a few highlights to the bushes.

6. Barn. Remove the mask from the barn. (If you used masking fluid, remask the horse.) Basecoat the barn with Red Oxide + Titanium White (2:1) and the ¼-inch (6mm) flat. Use Raw Umber + Titanium White (2:1) for the roof. Paint the dark, open area of the barn with pure Raw Umber. When that's dry, use the roof mixture to draw the uneven boards across the dark, open area. Switch to the no. 1 round for the small areas.

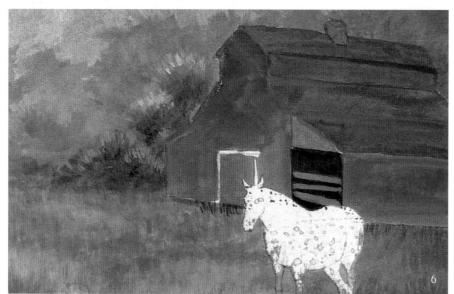

7. Barn and Tree. Shade the side of the barn and under the roof with Raw Umber, as shown in the photo. Highlight the edge of the roof with Titanium White. Paint the windows with Raw Umber and the no. 1 round. Transfer the tree with the white transfer paper, and paint the trunk with Raw Umber + a touch of Titanium White. Add delicate branches to the tree behind the barn at the same time.

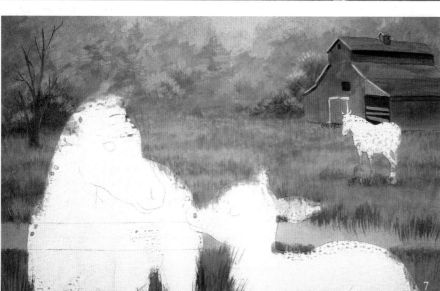

TIP

This painting requires a lot of color mixtures. Brush mix until the color meets your satisfaction. Never combine more than three colors, though, or you will end up with a muddy mixture.

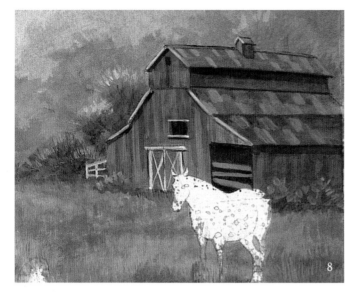

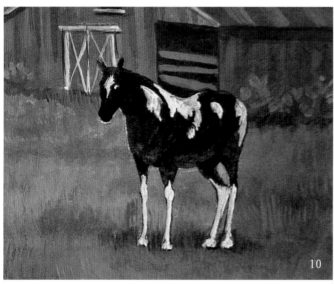

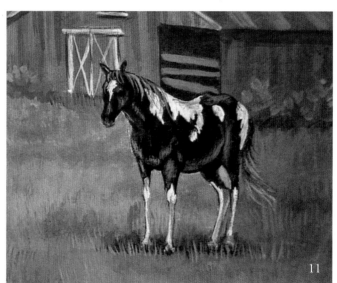

8. Barn. Add more Titanium White to the red barn mixture from step 6 and paint streaks on the barn with the ⅛-inch (3mm) flat. Next, paint thin Raw Umber streaks. Mix Titanium White + a touch of Raw Umber and paint slats on the roof. Paint the white trim and the little fence with Titanium White and the no. 0 round. Add details with Raw Umber. Finally, tap in some bushes around the barn with Sap Green Permanent + a touch of Titanium White and the ⅛-inch (3mm) flat. For the highlights use Brilliant Yellow Green + a touch of Titanium White.

9. Tree. With the ⅛-inch (3mm) flat, shade the left side of the tree with Raw Umber. Highlight the right side with Titanium White + a touch of Raw Umber. Mix Sap Green Permanent + Ultramarine Blue (1:1), and tap in the foliage and also the shadow under the tree. Mix Sap Green Permanent + Brilliant Yellow Green (1:1), and tap in the medium-hued leaves. Use pure Brilliant Yellow Green for the lightest leaves. Mix Medium

Magenta + Titanium White (1:1) and dot in a few blossoms. Glaze very thin Ultramarine Blue around the edges of the painting.

10. Mare. Remove the mask from the horse. Mix Raw Umber + Ultramarine Blue (2:1) and basecoat the horse with the no. 1 round. The paint should be diluted to an inky consistency. When that is dry, paint the mare's white spots with Titanium White.

11. Mare. Brush mix Raw Sienna + Titanium White (1:1). Paint the highlights on the horse with the no. 1 round. Also add the mane and tail with the same mixture. Add more Titanium White if necessary. Use the same mix to shade the white areas on the legs. Use a slightly thicker mix of Raw Umber + Ultramarine Blue to add deeper darks. Finally, bring a few blades of grass up over the feet with greens from step 5.

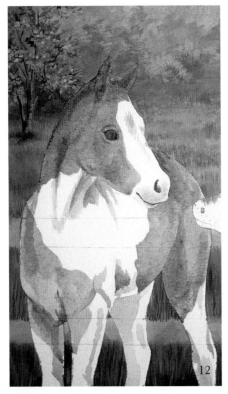

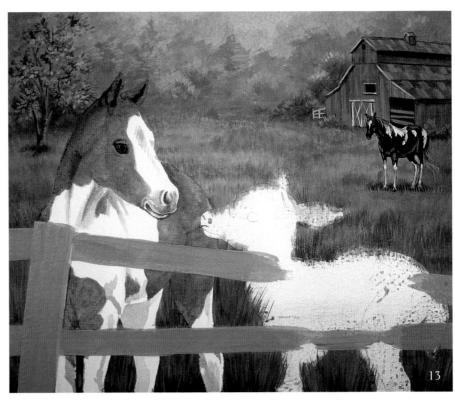

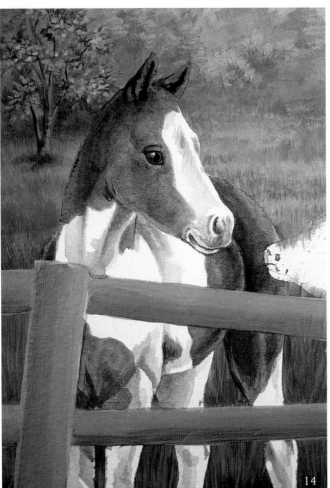

12. Foal. Remove the mask from the foal. With the no. 4 round, paint the brown patches with diluted Raw Umber. Paint the eye with Burnt Umber. Mix Burnt Umber + Ultramarine Blue (1:1); dilute with water until very thin, and begin shading the foal. Rub a cotton swab on the red pastel pencil to pick up some pigment, then rub the pigment onto the foal's muzzle (see page 19).

13. Fence and Foal. Retransfer the fence and basecoat it with a mixture of Raw Sienna + Titanium White (1:1), using the ¼-inch (6mm) flat. Glaze Burnt Umber over the foal's brown patches, and shade the muzzle with Burnt Umber. With the Raw Umber + Ultramarine Blue mixture from step 10, mixed thicker so it is quite dark, paint the pupil and outline of the eye and the inside of the ears.

14. Fence and Foal. Shade the fence with thin Raw Umber and the ¼-inch (6mm) flat. Mix Burnt Umber + Ultramarine Blue (1:1); dilute with water, and finish shading the brown patches on the foal, using the no. 4 round. Glaze the white areas with very thin Raw Umber. Add a Titanium White highlight to the eye with the no. 1 round (or a smaller brush, if you prefer).

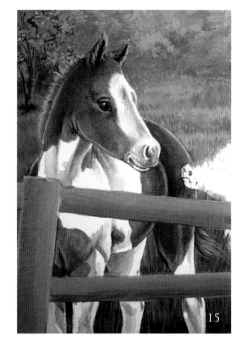

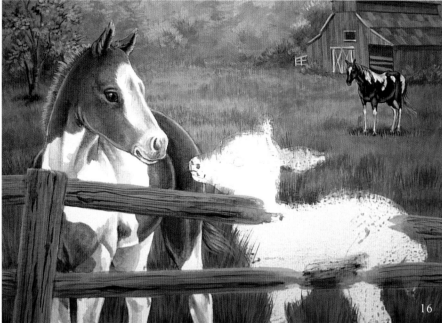

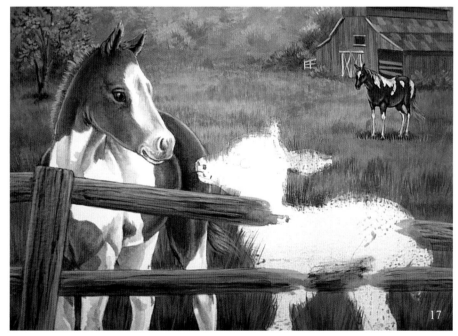

15. *Foal*. Add highlights to the foal with Titanium White and the no. 1 round. Glaze very thin Raw Sienna over the top. Paint the mane and tail with the ¼-inch (6mm) grass comb/rake and the fence basecoat mixture from step 13. Add details with the no. 1 round and Burnt Umber for the darks and Titanium White for the lights.

16. *Fence*. Add texture lines to the fence with Raw Umber and the ¼-inch (6mm) grass comb/rake. Draw some thicker, darker lines with the chisel edge of the brush.

17. *Fence*. Add highlights to the fence with Titanium White + a generous touch of Raw Umber with the no. 4 round. When that is dry, glaze Raw Umber and Olive over the top. If the mare seems too dark, add glazes of Burnt Umber + Titanium White (2:1).

18. *Morning Glories*. Transfer the morning glories with white transfer paper. Using the no. 4 round, basecoat the flowers with Light Blue Permanent + a touch of Medium Magenta. Basecoat the leaves with Brilliant Yellow Green + Phthalocyanine Green (2:1). If necessary, darken the grass behind the leaves with Sap Green Permanent.

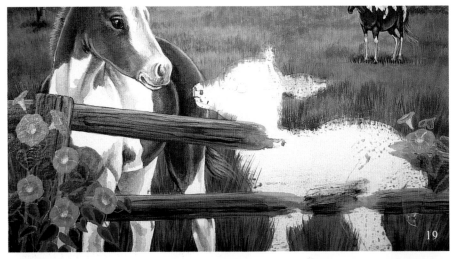

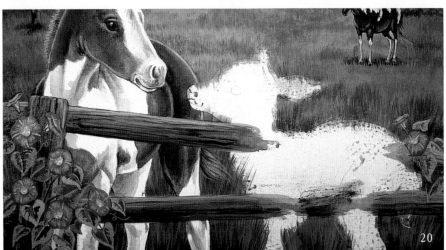

19. *Morning Glories.* Still using the no. 4 round, add Titanium White to the flowers as shown in the photo. Shade the leaves with Sap Green Permanent + a touch of Phthalocyanine Green. Add stems with the leaf basecoat mixture from step 18. Glaze Medium Magenta around the center of each flower.

20. *Morning Glories.* Darken the fence under the flowers with glazes of Ultramarine Blue. Add a little Titanium White to the leaf basecoat mixture from step 18, and paint highlights on the leaves. Add Ultramarine Blue to the flower basecoat mixture from step 18, and shade the flowers. Dot Naples Yellow Hue into the flower centers.

21. *Background Details and Fawn.* Paint details on the morning glory leaves with Sap Green Permanent and the no. 0 round. Glaze thin Sap Green Permanent over the leaves that are behind the others. Glaze Brilliant Yellow Green over the highlights. Stipple in some blue flowers by the barn with the blue mixtures from the morning glories.

Remove the mask from the fawn. Basecoat with diluted Raw Sienna as shown in the photo. For the eye use Burnt Umber.

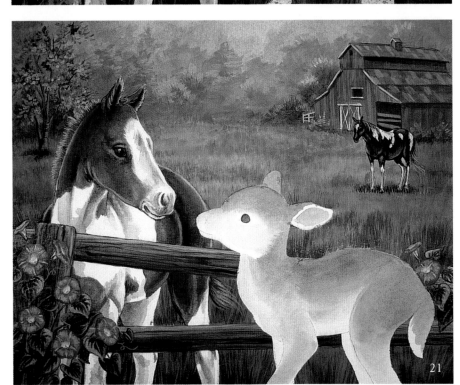

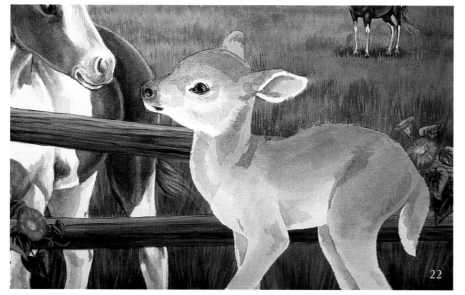

22. Fawn. Mix Burnt Umber + Ultramarine Blue (1:1), and paint the pupil and outline of the eye with the no. 1 round. Next paint the nostril and bottom of the mouth with the same mixture. Dilute the mixture with water, and glaze the muzzle. Glaze shading on the fawn with Raw Umber and the no. 4 round.

23. Fawn. Use a cotton swab to rub some red pastel from the pencil into the fawn's ear (see page 19). Mix Burnt Umber + Raw Sienna (1:1), dilute it to an inky consistency, and paint fur strokes with the ¼-inch (6mm) grass comb/ rake.

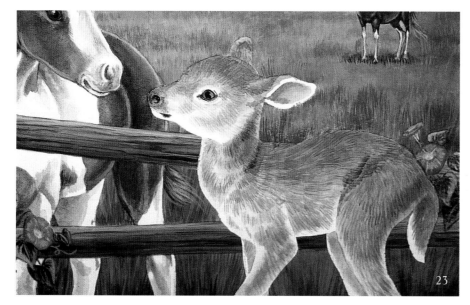

24. Fawn. Use the no. 1 round and Titanium White to paint a highlight in the eye and to paint white hairs in the ear. Mix Titanium White + Raw Sienna (2:1) for the midtone hairs. Paint the hairs individually with the no. 1 round or with the ¼-inch (6mm) grass comb/rake. Use a cotton swab to rub some golden brown pastel from the pencil to add softness to the fur. Add the spots with Titanium White, and rim the ears with Raw Umber.

Resources

PAINTS, BRUSHES & PAPER

Liquitex
P.O. Box 246
Piscataway, NJ 08855
www.liquitex.com
1-888-4-ACRYLIC

Silver Brush Ltd.
P.O. Box 414
Windsor, NJ 08561-0414
www.silverbrush.com

Winsor & Newton
P.O. Box 1396
Piscataway, NJ 08855
www.winsornewton.com

Canson, Inc.
21 Industrial Drive
South Hadley, MA 01075
www.canson-us.com

CANADIAN RETAILERS

Crafts Canada
120 North Archibald St.
Thunder Bay, ON P7C 3X8
888-482-5978
www.craftscanada.ca

Folk Art Enterprises
P.O. Box 1088
Ridgetown, ON N0P 2C0
800-265-9434

MacPherson Arts & Crafts
91 Queen St. E.
P.O. Box 1810
St. Mary's ON, N4X 1C2
800-238-6663
www.macphersoncrafts.com

Maureen McNaughton Enterprises
RR #2
Belwood, ON N0B 1J0
519-843-5648
www.maureenmcnaughton.com

U.K. RETAILERS

Atlantis Art Materials
7-9 Plumber's Row
London E1 1EQ
020 7377 8855
www.atlantisart.co.uk

Crafts World (head office)
No. 8 North Street
Guildford
Surrey GU1 4 AF
07000 757070

Green & Stone
259 Kings Road
London SW3 5EL
020 7352 0837
www.greenandstone.com

Help Desk
HobbyCraft Superstore
The Peel Centre
St. Ann Way
Gloucester
Gloucestershire GL1 5SF
01452 424999
www.hobbycraft.co.uk

Index

The best in art instruction is from
NORTH LIGHT BOOKS!

Fresh & Fabulous Flowers in Acrylics

Recreate the simple beauty of a bouquet fresh-picked from the garden on a summer day. Popular artist Lauré Paillex offers complete instruction on designing and composing floral paintings using techniques that are fun, loose, free and forgiving. Ten simple and ten complex step-by-step compositions let you practice and perfect your painting and composition techniques.
ISBN-10: 1-58180-976-X, ISNB-13: 978-1-58180-976-3, paperback, 128 pages, #Z0786

Fast & Fun Landscape Painting with Donna Dewberry

Donna Dewberry makes landscape painting fun and easy using sponges, large brushes and her popular one-stroke painting technique. Fifteen step-by-step demonstrations show you how to paint a complete scenic landscape on canvas in less than an hour. You will find a variety of landscape scenes to choose from including old-world Tuscany, mountains with reflective lakes, seascapes and tropical beaches, lush green woodlands, garden scenes and spectacular fall foliage.
ISBN-10: 1-60061-025-0, ISBN-13: 978-1-60061-025-7, paperback, 144 pages, #Z1309

Painter's Quick Reference: Cats & Dogs

Paint your favorite furry companions! More than 40 step-by-step demonstrations clearly show how to accurately render a wide variety of popular pet breeds. Special detailed instruction on painting paws, fur, noses and eyes helps you get details just right.
ISBN-10: 1-58180-860-7, ISBN-13: 978-1-58180-860-5, paperback, 128 pages, #Z0125

Adorable Animals You Can Paint

Jane Maday shows you how to capture the cuddly features and precious expressions of puppies, kittens, bunnies, chicks and fawns in ten start-to-finish demonstrations. Twelve additional mini-demos offer complete guidance for getting all the details just right, including fur, feathers, eyes, noses and whiskers.
ISBN-10: 1-58180-738-4, ISBN-13: 978-1-58180-738-7, paperback, 128 pages, #33415

These books and other fine North Light titles are available at your local arts & crafts retailers, bookstores, or from online suppliers.